It's a Lot like Dancing

An Aikido Journey

It's a Lot like Dancing

An Aikido Journey

Stories by *Terry Dobson*

Edited by *Riki Moss*

Photographs by *Jan E. Watson*

Frog, Ltd.
Berkeley, California

It's a Lot Like Dancing: An Aikido Journey

Published by Frog, Ltd.

Frog, Ltd. books are distributed by
North Atlantic Books
P.O. Box 12327
Berkeley, California 94701–9998

Cover by Bill Barrett
Layout by Jan E. Watson
Book design by Paula Morrison
Typeset by Catherine Campaigne

Library of Congress Cataloging-in-Publication Data
Dobson, Terry.
 It's a lot like dancing : an aikido journey / stories by Terry
Dobson ; edited by Riki Moss ; photographs by Jan Watson.
 p. cm.
 ISBN 1-883319-02-1
 1. Aikido. I. Moss, Riki. II. Title.
GV1114.35D64 1993
796.8'154—dc20 93-37479
 CIP

2 3 4 5 6 7 8 9 / 97 96 95

This book is dedicated to the memory of Terry Dobson.

I loved in Terry Dobson
his enthusiasm for the noble impulse.
When he knew a radiant idea was near,
his eyes and heart opened wide
and he staunchly kept his place
until the wave arrived.
His tremendous discipline as he waited
gave courage and life to others.
He kept his radiance
when the wave of death approached.
To me, he was a gift I hardly deserved
and a great soul
that made the world sweeter to me.

<div align="right">

Robert Bly
August 23, 1992

</div>

Table of Contents

Preface

Everyone who has ever heard Terry Dobson tell a story has urged him to write. He was a mesmerizing bard, drawing people wherever he went. Sometimes riotous, often sage, and always human, his stories would circuitously gather up the frayed edges of his curious life and we would all feel the better for having heard him out. Every now and then, he even wrote a story down. One, known as "The Train Story" became something of a legend, turning up in the pages of *Reader's Digest*, in anthologies, at Ram Dass' lectures, and as the subject of a documentary film.

Terry called himself an author, but in truth he hated to write. The worst fate for him was to have to go into a little room alone, shut the door, and commit the appalling act of putting words down on a piece of paper. He used stunning inventiveness to avoid writing: He once cut two cords of wood into six-inch pieces, he routinely rearranged the landscape, he marbleized the bathroom walls with a tiny brush. He spent hours trying to change the right margin on his word processor, a tool he never could master.

He had first seen Jan's portfolio of Aikido photographs when she interviewed him for *Aikido Today Magazine*. Jan told him she wanted to do a book that would incorporate Aikido words with her images. Terry didn't say much at first, but later, back in Vermont, he started to think about a possible collaboration. He called her, and Jan sent the portfolio up to Vermont.

Although I didn't practice Aikido, I found that I was tremendously moved by these pictures. They seemed to me to be describing a universal energy, a power which Jan somehow made visceral as well as visible, and which was exactly what Terry was talking about in his stories. The two of them seemed to be partaking of a similar mystery which, while it emanated from Aikido, was part of the universe, a "wild physics" caught by a willfully startling photographer and a poetically rambunctious storyteller. Bodies appear and disappear into the surrounding space, as if charged with the same ions as the atmosphere. The stories did the same.

Seeing these similarities, we decided to pursue the collaboration. During the months which followed, Terry's health started to decline. It turned out that he had a rare and severe lung condition. Medication wasn't helping. We were frantically looking for answers and finally decided to try experimental surgery. The winter wore on. Jan kept in touch. It seemed that it might be helpful to get things rolling on this book, as a kind of spiritual lift. At first, Terry resisted: he felt terrible, it would be too hard, he couldn't do his share, he didn't have the energy. But then, I think he started getting energized by the challenge of running a race, producing a book against impending doom, and so we decided to go for it.

He summoned up everything he knew from his lifetime with Aikido. I knew he was very fragile, but I didn't really understand how hard this was going to be for him. One night, he sat down heavily at our round table and said, very seriously, "You know, I'd rather die than write this book." I didn't quite get it then. I didn't know that he would ultimately avoid writing this book and that we would just have to do it for him.

In early spring, Jan flew up from California with Kaz Tanahashi. Terry and Kaz had known each other for 30 years, ever since they had

trained together with Morihei Ueshiba. We put a tape recorder in front of Terry and just let him loose. For the better part of a week, we took turns cooking and watching over him, not letting him get too tired, creating our days around his needs. It was really a magical time huddled around the warmth of our wood stove, the big black dog at our feet. There was a feeling of protection, of creation, of necessity. We didn't do him much damage: in fact, he seemed strengthened in spirit, nourished by his audience, fed by our enthusiasm. We used Aikido and we used it well. Terry came through his surgery that fall and lived almost another year in great spirit and good will.

But he stopped pretending to write. He missed Jan's deadlines and grew immune to her growing frustration. Instead of transcribing his tapes, he started teaching me how to do it for him. He gave me lectures about the differences between oral and written storytelling, about the publishing business, about editing. He revealed the mysteries of his files, listened to the transcripts with me, and kept me appraised of negotiations between himself and Jan. He kept reminding me that I had been present at those March taping sessions for reasons I would do well to trust and not question. Looking back, it seems as though he was preparing me to finish this work. It was only after his death, when I met Richard Grossinger, Terry's publisher at North Atlantic Books, that I realized he actually had gotten us to write the book for him.

I spent six months transcribing the tapes. Material came in from other sources, as well. I had transcriptions of previous taped interviews with Donna Winslow and John Stone. Sandy Jacobs contributed an entire series of stories that he had taped years before. Transcribing those tapes was tremendously healing for me. Those dark Vermont nights were filled with the sound of Terry's voice wheezing its way through his life and his thoughts, the stories rolling out with his marvelous clarity.

In January, I packed up the tapes and the big black dog and joined Jan in Point Reyes, where it rained for twenty-two days straight. The drought ended and Inverness became an island. I was back where Terry had died, surrounded by the people who had been with me then. I felt as though I were on a big, dark raft heading in the opposite direction from the rest of the coast, just me and these people—Jan, Rhiannon, David, Nancy, Elizabeth, Sandy, Gale—bonded with an endless tape loop of Terry Dobson. It was during this month that the book really began to take shape.

We didn't want to illustrate the photographs with the stories, or vice versa. What we did was constantly move the images around, until they matched the words in instinctive ways. We looked for that intuitive sense of related energy for pairings, and we often laughingly begged the Big Guy to help us out.

Of course, he did. Terry Dobson was a wonderful, earthy, rollicking individual, a riveting storyteller, and a compassionate man. Aikido was his lifelong obsession and the field upon which he fought his most memorable battles. And while his stories are part of the Aikido legend, Aikido is only part of the great breadth of his stories. All of us, Aikidoists or not, can relate to his life and can learn from his experiences. He was fascinated by us, and in turn, we can't help but be enchanted with him.

<div align="right">
Riki Moss

July 1993

North Hero, Vermont
</div>

It's a Lot like Dancing

An Aikido Journey

Chapter 1

A Mind to serve for the peace of all human beings in the world is needed for Aikido and not the mind of one who wishes to be strong or practices only to defeat an opponent.

—Morihei Ueshiba Osensei

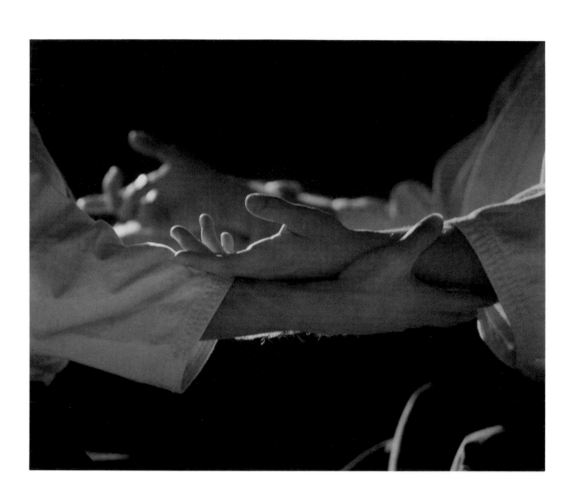

I went to Japan to work in a kind of rural Peace Corps situation. It was not going well. I was feeling depressed and lonely, actually suicidal. I was seriously thinking of ending my life, but decided that I really ought to see Tokyo before doing that. So I went to Tokyo. On the train, I got a cinder in my eye and had to go to a hospital to get it removed. The irony of my situation did not escape me: here I was getting a cinder taken out of my eye before I killed myself.

While I was waiting there for a doctor, I was reading the *Tokyo Times* and saw an announcement for an Aikido demonstration in Yokohama. I had been studying Judo and Karate in the Marines. I had heard about "Aikido," and it was one of those very chic things that nobody knew anything about. I figured, well, I'll go check it out and maybe there would be something there that would change my chemistry enough to give me a reason to hang around this planet.

There were about thirty Americans in the Bob Chickering Theater when I walked in, late. On the stage, I saw a man throw another man across the room. I immediately understood exactly what they were doing; it seemed absolutely perfect to me. I forgot about suicide. Whatever I saw shook my world completely. My understanding of Aikido was as clear to me then as it is now. I couldn't do it. I couldn't say anything about it. I just knew without a doubt that the rest of my life would be in Aikido.

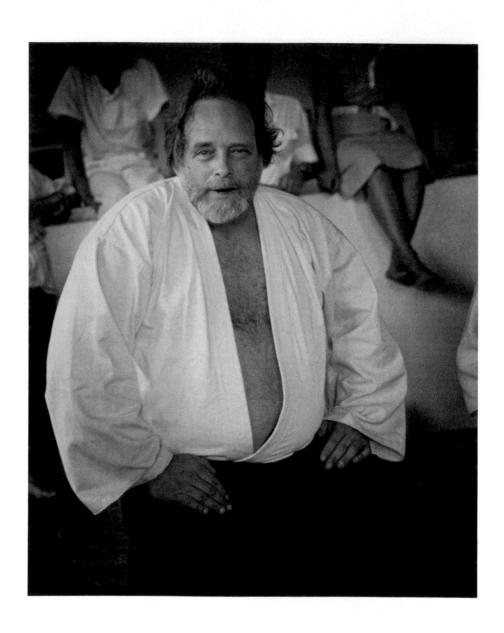

I was so happy to have found Aikido. But I didn't have anyone to practice with. There was an apple tree right outside my window. You know how sometimes the boughs of an apple tree have a certain curve to them? It's a little bit like a woman. I started practicing with that apple tree, breaking many branches until I learned to be more gentle. My first partner in Aikido wasn't even human. It was a tree.

"Ai" means "to harmonize, to meet, to come into agreement with "ki," which is energy. "Do" is the way to do that, the way of harmonizing with energy, or harmonizing energy. The seat of *ki* is thought to be located two inches above your navel. It's an imaginary point. You can cut the body open but there's nothing there. It seems that all movement and all energy proceeds from this place. When we meet somebody, we have what's called "a gut reaction." We recognize the truth in that. We talk about "hating somebody's guts." It comes from down here. All spirit initially comes from this point.

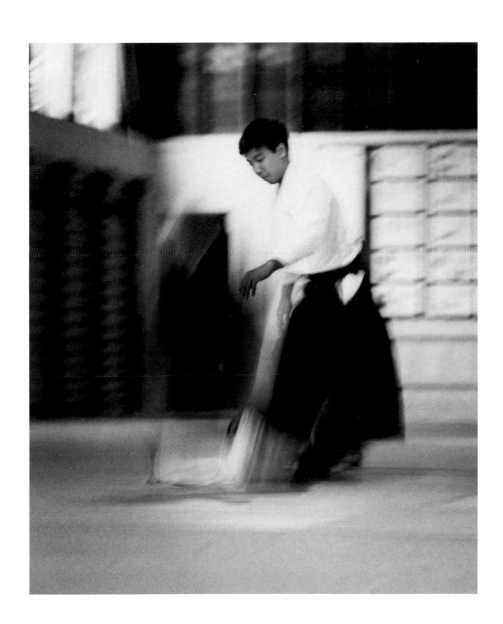

Osensei used to make these shapes as he was demonstrating: circle, square, triangle. I never understood what he meant by them; I was burning to know the meaning of these symbols. It was an unspoken rule that you didn't go ask him questions. I thought about it for four, five, even six years.

One day, everybody in the dojo got into spring cleaning. We were really going at it, tearing the place apart. It was a gorgeous day, and I found myself alone with Osensei on the veranda. We had just finished a job and it was obviously time for a break, so we sat down together.

I thought, what the hell, one question in six years ain't so bad. I asked him, "Sensei, I notice when you teach you frequently mention circle, square, and triangle. I've thought about it a while and I don't understand the meaning of these symbols. I wonder if you could help me solve this problem. Please explain." He looked at me for a long time. He looked down, he looked up, and he looked around. And I'm waiting, right?

He said, "Terrusan, you know you should go find out yourself." Then he got up and walked away. And I thought, "That's a piss-off, you know? All you have to do is say a couple of words, you don't have to be so Zen all over the place."

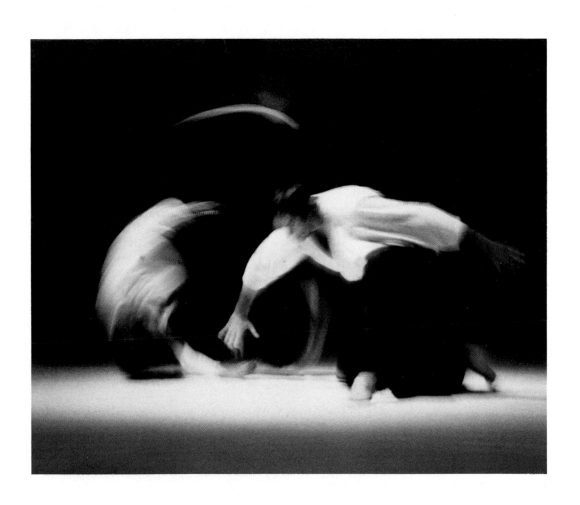

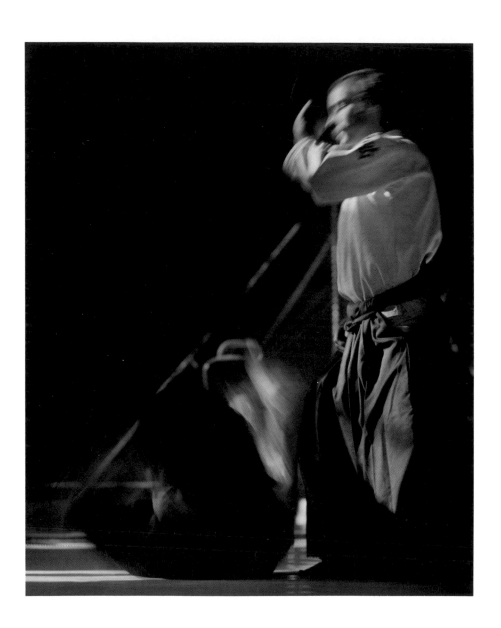

The prime quality of earth is balance. The prime quality of fire is focus, pointedness, acuity. The prime quality of water is adaptability. As a person, you have the qualities: *balance, focus, adaptability.* You excel or lack in one of these areas in any particular situation. When you are in a high stress situation and act appropriately, then you are balanced, focused, and adaptable. These are the qualities of centeredness.

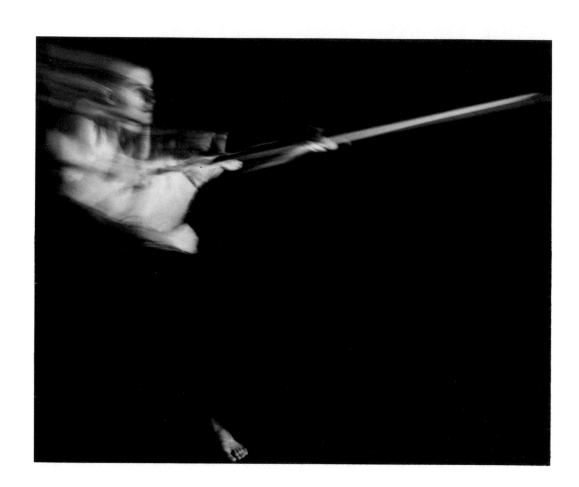

The secret of focus is virtuous intention. Nothing else. Any fool can focus. Any fool can concentrate. But the real life, and deathness, comes in *why* you are focusing. The reason that you are focusing is important. The techniques you learn in Aikido are not weapons. They are tools which can be used to save a life. If you use them as weapons, you will get cut by them. You will hurt somebody or get hurt. If you use them with virtuous intention, you will go right through the opposition. I stole this theory from 150 Japanese sword teachers.

Aikido makes you look at your impatience, your arrogance, your meanness, cruelty, clumsiness, cowardice—all those qualities in your-self that you may need to look at. It'll show your bravery and com-passion, love, joy, and sweetness, and it will show you those qualities in other people. Men and women, men and men, women and women will be able to touch each other in a nonviolent way. Not only touch each other physically, but see each other in a real way. You can't hide out on the mat. You can't pay somebody to do a roll. You can't use sophistry. When you're heading towards the mat at sixteen feet per second, you better do something if you want to come out of it all right, and that something is inevitably to relax. It's very easy to clutch up under pressure, but it's really the mark of you if you can relax under it. Once you learn to relax, you can deal with some big knee-breaker coming at you fifty miles an hour with a solid punch, in a way that doesn't hurt either one of you and feels good for both. It's a powerful rush.

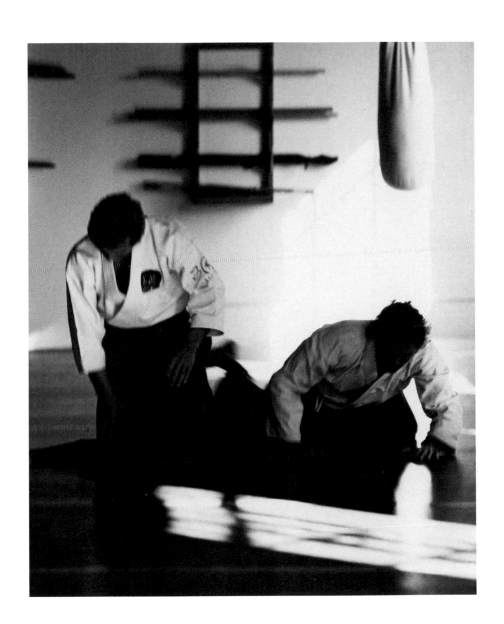

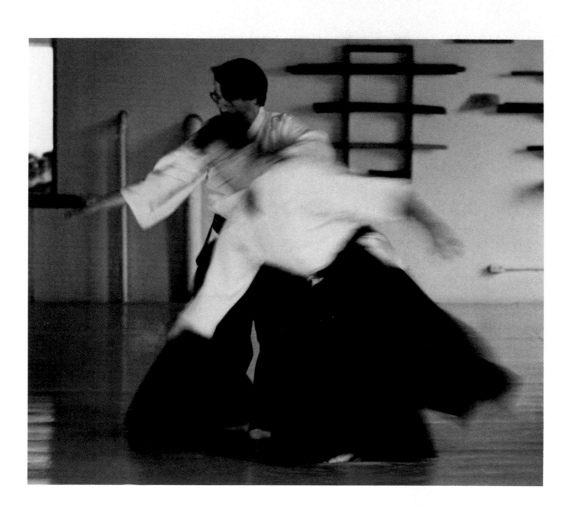

Osensei said that it is easy to control people. What is much more difficult is to control them without using tricks. There are many things he did that I can't explain, like the way in which he would hold out his *bokken* and ask people to push on it. Since it would always be the same people, Subano, Kenai, and Saotome, and he'd never include me, I'd think, oh that son of a bitch. This is all rigged, this is all funny.

There was a big demonstration one day. He had three guys pushing on the *bokken*. I slid in between Chiba, and Subano. I hit that *bokken*. I was certain it had to move. Even if you run up against a wall, there has to be some movement. But there wasn't any, none. It was like hitting solid steel. Now, how did he do that? I have no idea. All I know is that I was dealing with something that could not be explained from my basic experience as a human being.

In any love affair, there are many first meetings. There is the literal first time you meet, then the first time you really *see* and feel the other person, and finally, the first time it all comes together.

The first time I really saw Osensei was when he asked me to attack him. I'd watched other people attack him, and it was interesting—here's this little old man, and these guys attack him, and they fall down. But then he asked *me* to attack him. I didn't know what that meant. In my culture, you're not supposed to hit old people on the head. I knew that he wanted me to hit him on the head as hard as I could. This terrified me because not only was it a cultural taboo, but I could see a lot of black belts sitting around, and there was no doubt in my mind that they were going to kill me if I hit Osensei on the head and killed him. Then I thought, if I kill him, and they kill me, then I won't have to study Aikido. I'll be dead.

What would happen if I didn't hit him on the head? He and I could have reached an agreement: "O.K. I agree not to hit you, and all you have to do is yell at me and I'll fall down." I wouldn't have to study Aikido in that case either, because that would only be theater and I don't care about that shit.

The first time I attacked him, I don't know how he did it, but he put me on the ground. I don't know what he said, but what he meant was, "is that the best you can do, is that the most concentration you can give me?" It really pissed me off. I thought, "Well, fuck you. I don't care how old you are. I'm going to try for real." So the next time, I really tried to hit his head. The next thing I know, I'm looking up from the ground. He's looking down and asking, "You all right?" It was as if there were no passage of time; one moment I was standing and the next moment I was on the floor. My conscious participation had not been required. It occurred to me that this might have been some kind of a trick, a form of participatory hypnosis, a self-induced trance, or

something like that. But even if it was some kind of trick, I wanted to know how to do it.

Although I was at the dojo every day, it was quite a while before I *saw* him again. These epiphanies, these moments of lucidity, were rare, because not only did he have to be in a certain place, but I did, too. One day, in class at Humbu Dojo, for some reason I suddenly snapped my head around in Osensei's direction. I don't know why I did this. He was looking at me; I caught him judging me, evaluating me. He was looking at me in the way I had looked at him, to see what kind of character I had. He was very sneaky that way. He would look at you when you weren't looking. When you knew he was looking, he wouldn't pay any attention to you

The first time I was allowed to be alone with Osensei on a long trip, I went as his bag carrier. All the other Japanese were upset that Osensei wanted me to accompany him. And it was the blind leading the blind. Here we had Osensei, our resident mystic, talking to the persimmons when he was supposed to be on a train. And I, who didn't even speak the language, was supposed to guide him around. High efficiency, it was not.

We were going to Osaka. I knew that I was supposed to be committed enough to Osensei to throw myself in front of a train if need be. I felt that the job required my total concentration. So, when we got to the station, I paid the driver, jumped out of the car, and leapt over to his side of the cab to help him out. You have to keep in mind that he was four foot ten and eighty years old. It's noon at the old Tokyo Station and it's crowded. I'm determined that nobody should run into Osensei. I would be mortified. I've got the bags and I'm looking ferocious. "Don't fuck with my teacher, man." I'm sort of swinging these bags. I must have hit forty people who were trying to get out of my way. I'd hit them and I'd have to say, "I'm sorry" and they'd say, "I'm sorry."

Osensei moved like a knife through butter. Nobody looked at him, nobody saw him. I'm trampling old ladies. He was on the platform fully a minute before I got there. "What are you doing?" he said. I'm just drenched with sweat. "Are you all right?" he says. "I was afraid you were lost."

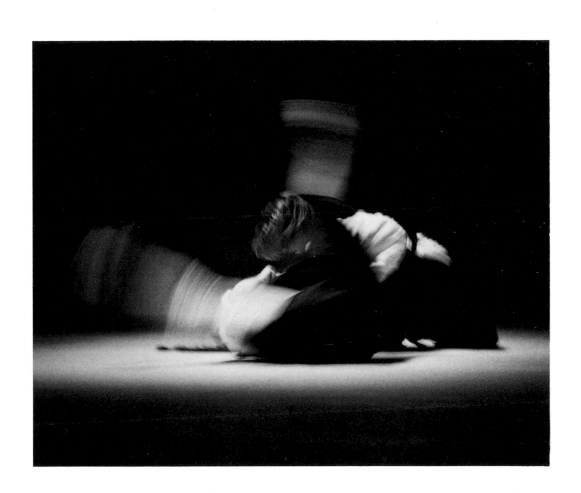

He was a little tiny guy. You're supposed to hit this little guy but you can't find him, he's not there. Then the little tiny guy gets in the middle of eight or nine other people and they can't find him. So he's invisible, unavailable.

He had endless tricks. He took pleasure in them, but not personal pleasure. I know, because I spent time with him and I know what he did when nobody was looking. I went on a trip with him to Kyoto, for three or four days. He had almost no meetings with anybody. We stayed in this house, in rooms right next to each other. I could hear every move he made. Whatever he needed, I would provide for him.

What he did during those days was pray. That's what he did. That's his point of origin. He didn't go to the movies, go out on a date, or entertain a bunch of people. He just talked to God. His truth was that he believed what he was doing was the way to reconcile the world, to bring about peace. When he wasn't doing that, he didn't reach for ego support. He was self-contained. I think that's extremely important. Throughout history there have been people like him whose ability to deal with opposing force in miraculous ways was profound, was extensive. That was their preaching. Just like some people are able to handle snakes without being bitten. Or others are able to heal without touching.

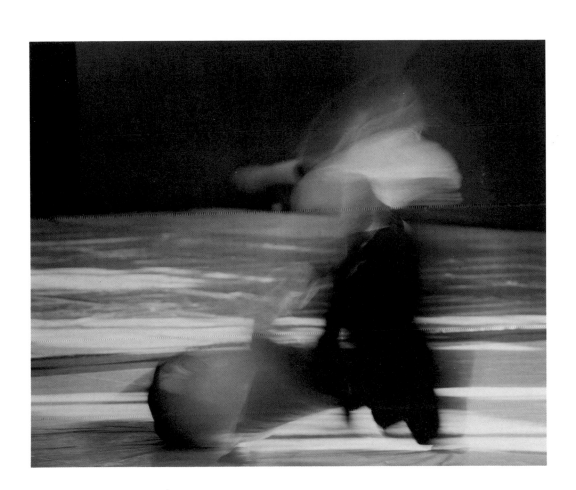

Once, when we were traveling together, I made his bath up for him. Me and Kenai. We got the wood, chopped it, and made the bath. It was just a cement bowl, and you make the fire under it. It's not big, I could barely get into it. The rule is always that the Sensei goes first. If he even lets you have a bath, there was no question that I, being the last Uchideshi, should be last. One night, Osensei made the fire and went away. I was fanning the fire. I was about to go call him and say, "Sensei, your bath is ready," and there he was.

He spoke to me as though he were speaking to a little kid. He made me take my clothes off. "Take some water," he said. I had to stand next to the bowl and clean myself before getting into the bath. I had to pour it over my head and soap up. "Now wash behind your ears, get in your ears, that's good." Just like a little kid. Then he said, "OK, get in the bath." I said, "Sensei, please." He said, "Get in, get in." So I got in the bath, and sat with my knees up to my chin. I said "Yeah, it's very good." Actually, it wasn't comfortable at all. I was very embarrassed. But, he would do that sometimes. He could kill you with sweetness if he wanted to.

Sometimes he would treat me like just another deshi. In the morning I would take his false teeth, and hold his sleeve while he washed his face and brushed his teeth. He would not give me any recognition, and I wouldn't expect any. I wouldn't try to get any. I wouldn't even hand him the best towel. I wouldn't do any of that bullshit, I would just give him any towel. I really liked that, it made me feel at home. Sometimes he'd be talking about life and death, and I'd be sitting there thinking about women. He called me "Terrusan" which is "little dog," the way you call a little dog. He would make it very cute sometimes.

But then, sometimes, it would be very obvious that I was just there for show. I'm big, he's little, it's a perfect theatrical match. He would call for me to grab him and he'd say, "Why do you grab my beard? I'm an old man." The first time he said it, I was terribly embarrassed because it was in front of a whole bunch of people. Everybody laughed. He said, "I'm just an old man, I don't have many hairs in my beard. If you grab them and pull them out, I'll look terrible." Everybody laughed. About a week later, we went somewhere else. He called for me to attack him. This time, I was very conscious and I know I didn't touch his beard. But he said the same thing again. So I knew it was a hype. Everybody laughed. It was a good joke. It was OK, but behind that I was thinking wait a minute, wait a minute. I'm just here to play his straight man, to make people laugh. He doesn't give a shit about me, it's just because I'm big and I'm a *gaijin*. That was definitely a part of it.

I felt about Osensei in many ways like I feel about my dog, or how I feel about this hatchet. I like to chop wood with it. I don't know anything about it, all I know is that the hatchet better know how to chop wood, because I don't. I only know enough to pick it up. The rest is done by the hatchet. If the dog wants to go out, well, I can open the door, she's got to do the rest. I only know enough to put myself in Osensei's path; I don't know what I'm doing or how to do it. Let's hope he does. It's in between trust, love, and surrender.

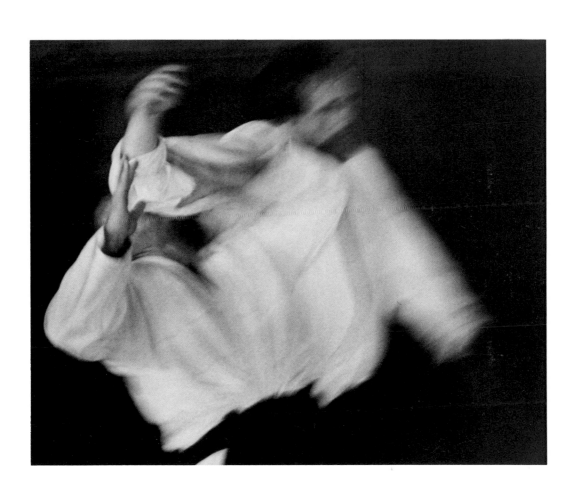

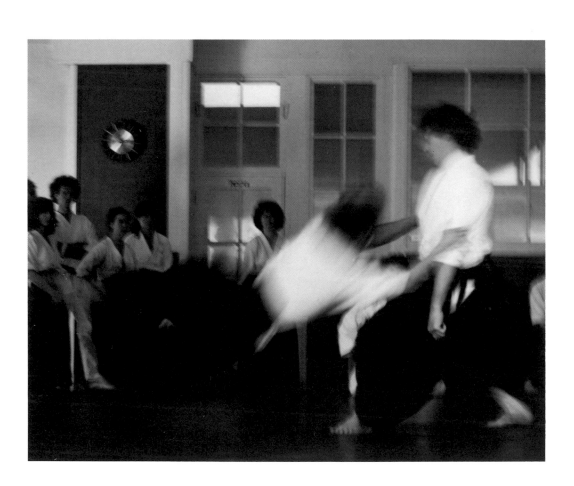

Sure, I wanted the love of a father, since I never had one of my own, but how could I get love from Osensei? Am I going to charm him? Am I going to tell him stories? Am I going to bring him sweets? No. There's no way I can get into him. I can only let him get into me. Although there are many things about my relationship with Osensei that I'm ashamed of, I am proud that I trusted him to *see* me. I felt that he was honored in his turn by his willingness to do that.

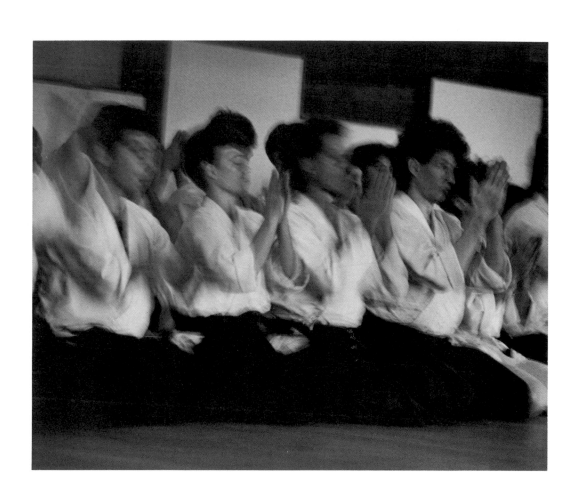

I've never felt for any member of my family the way I felt about Osensei. He was family to me. If I had to explain myself to him, then I didn't want him. My own family couldn't understand me, so if Osensei couldn't *perceive* me I was lost. There's a difference between a father and a mentor: a father loves you, but can't understand you. He doesn't know why you want to be a painter or whatever. But a mentor doesn't love you, he has no confusion about you. Because love does not cloud his vision, he can *see you clearly*. He can see how you could be a painter. I had to believe that Osensei saw me that way.

Chapter 2

True Budo is a work of love. It is a work of giving life to all beings, and not killing or struggling with each other. Love is the guardian deity of everything. Nothing can exist without it. Aikido is the realization of love.

—Morihei Ueshiba Osensei

I wish you would see me not as a spiritual leader, but rather, as a mechanic. I consider myself a mechanic. I'm a *transmission specialist* of a sort. I'm working on the transmission of *ki,* of intention. I'm heir to a legacy that comes down from many generations, regarding point, or presence. Many Japanese warriors got cut down or killed; a lot of people paid in blood to learn lessons about being centered under fire. I'm not the repository for the entire sum of knowledge on the subject, but I have been close to some good teachers and I do know something about it.

While I don't necessarily want to prepare you for the OK Corral, perhaps something I say may be of help to you.

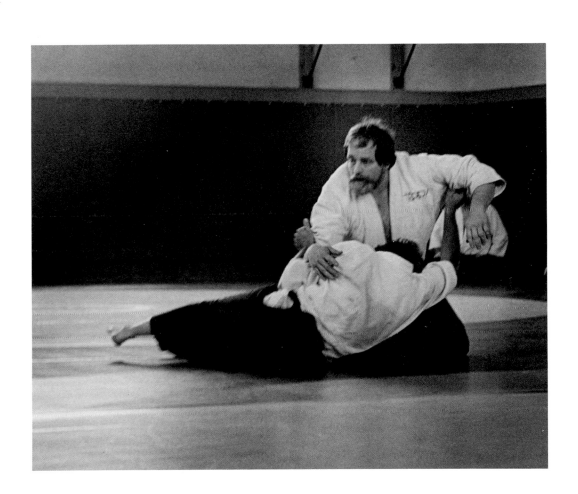

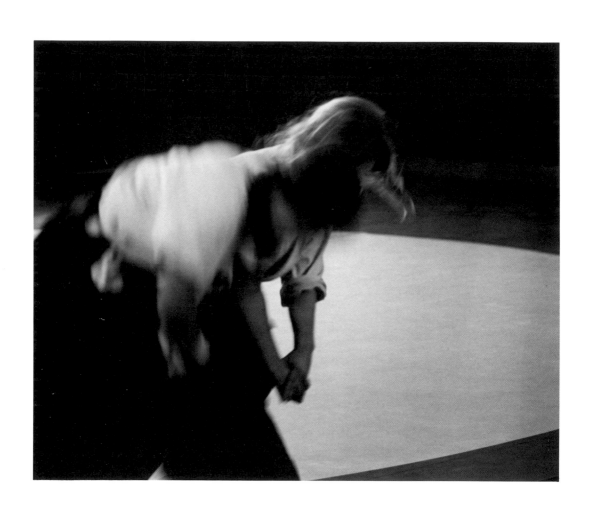

In the martial experience, you learn that it's very good to be close to your opponent. When I'm close to him, I know exactly where he is, what he's thinking, what he's likely to do. I can control, direct, relax, quiet, and restore this person by being close to him.

Increasingly you realize there is nothing separating us. You are a bunch of exploding atoms and so am I. What separates us is everything in us that wants to separate from each other. Once you let go of wanting to separate, you can begin to see that we are all one.

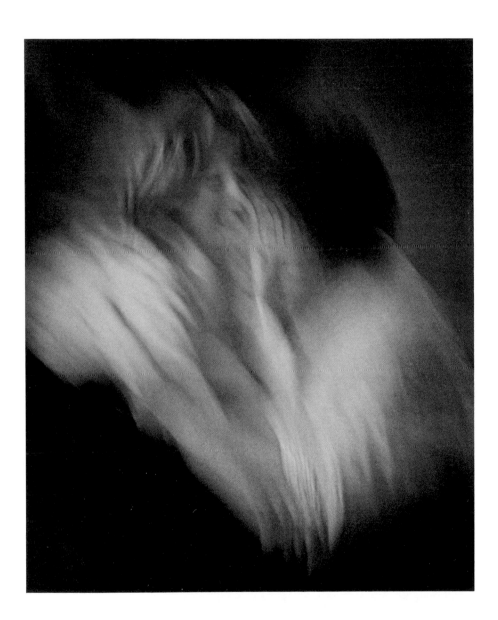

The Mohawk Indians, who live not far from me in Vermont, have a tremendous feeling of anger. They believe they face real genocidal opposition on the part of the whites. To deal with their feelings, they have a traditional ceremony called "Kill the Enemy." Let's say I have an enemy. Let's say it's Yamada. I choose several other people to help me, to join me in a sweat lodge. Our task will be to think of every positive attribute of Yamada. "He's tall. He's handsome. He's very strong. He's not lazy. He gets up early, blah blah blah." We do that for a set period of time, maybe a few hours. By the end of that time, since only his positive aspects have been focused upon, we've essentially killed the enemy. He's too good to be our enemy, we like him too much. We are in harmony. Pretty soon, it's impossible for me to remember Yamada was my enemy.

In order to have a war, the enemy must be kept alive.

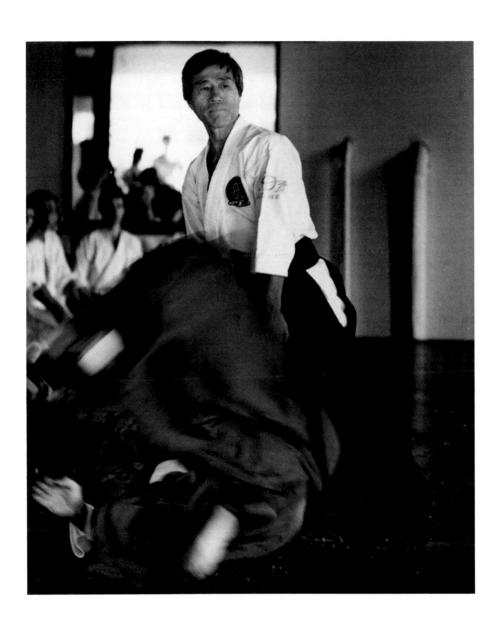

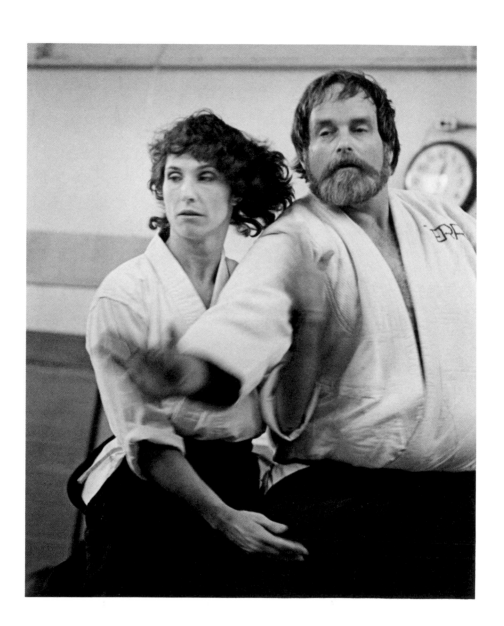

Conflict can be resolved. It will be resolved. You can do it. You must do it. Things are very fragile. Relationships are very, very fragile. This whole thing seems solid, feels solid, is solid. But it can all end in an instant. The more you understand this, the greater the delicacy with which you will treat one another and yourself.

The next time you are in conflict, don't resist. When the person you are dealing with finds no resistance, they change. They go to another place. It's so simple in theory and difficult in practice. You get into arguments because you think you are right. So stop thinking you are right!

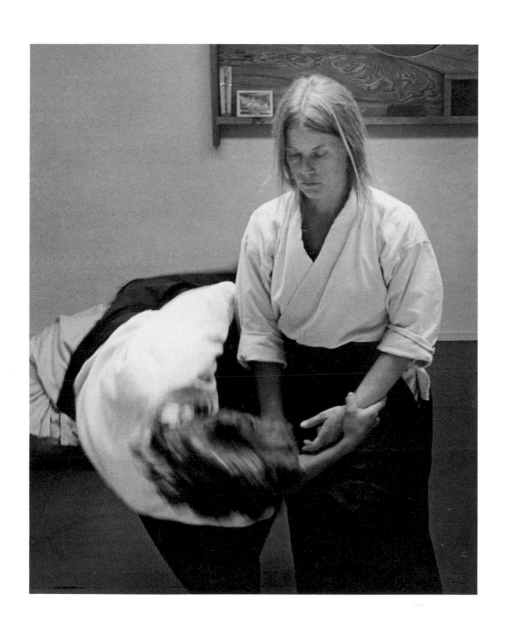

It is your responsibility to protect the person who is attacking you. If you are unfairly accused of something, you can protect your accuser by looking at him with compassion. You try to understand why he unfairly accused you. Then you withdraw your venom from your response to him. This is extremely sophisticated, because it is difficult for your enemy to attack you when you are in a compassionate mode.

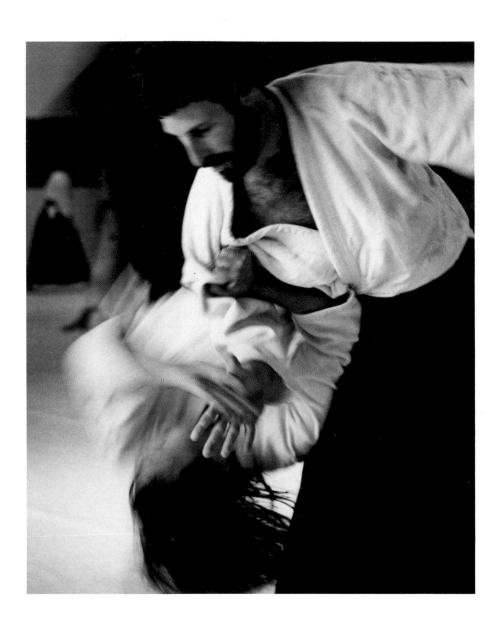

No one is going to mess with my brother. He is my flesh and blood, I want only for his well-being. At the same time, I don't have to take any shit from my brother. As long as I am sincere in this, we won't fight. It would be senseless. Have you ever seen a boxing match where anyone punches himself? Fighting my brother is fighting myself; I am not going to punch myself. So, make a brother of your enemy.

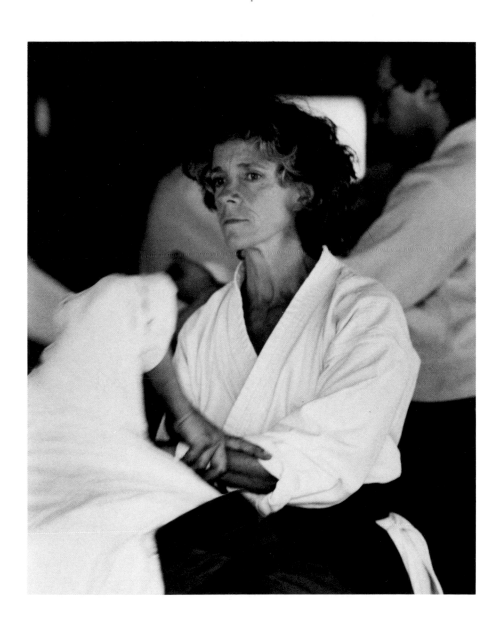

To say, as Osensei did, that "you are responsible for protecting your attacker, for not hurting him," is extremely sophisticated. It works to your advantage and it works to his advantage. It is an all-win situation. It's easy to do, if you know how to keep your center. You learn to see similarity: You each have two eyes, two arms. Whatever level you want to deal on, the spiritual, physical or psychological, there is similarity. The more you operate in the realm of similarity, the harder it is to imagine that anyone would want to conquer anyone else.

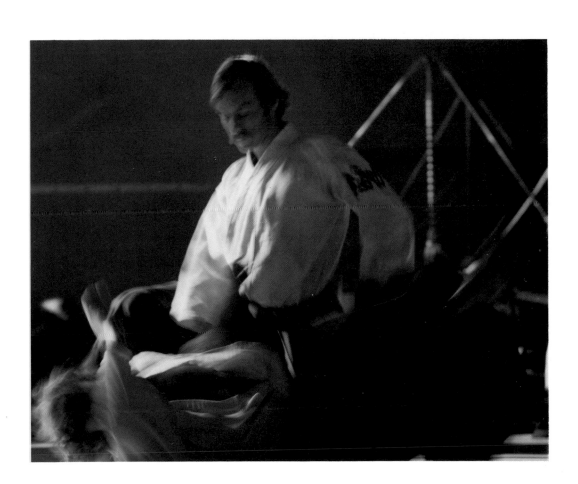

We are all for nonviolence, but there are times when the right course of action is to fight like hell.

I was waiting to be seen by a doctor in the Emergency Room of Roosevelt Hospital in New York City. I had broken my shoulder, had had an operation, and now one of the steel pins was working its way out of my skin. It was 3 AM and I had been waiting for hours, entranced by the entertainment offered me by the participants in one of the city's least elegant public hospitals.

It was a hot, August night and most of the doors were open to the street. All of a sudden, I heard a roar. Ahhhhhhhh! from far away, but growing closer. Everybody sat still, wondering what it was. Was it an animal? Was it a human? What was it? Then, screaming "Ahhhhhhhh!" at the top of his lungs, this Puerto Rican guy burst into the Emergency Room. He was a big man, a body builder or maybe a professional wrestler. Blood was trickling down his totally shaven head. He was wearing a pair of bikini underpants and nothing else. No shirt, no shoes, no pants, nothing.

He came in running at full speed, screaming at the top of his lungs. He was the most frightening thing you've ever seen in your life. He ran past the nurses' station. Beyond it, there was a door on his right sheathed in lexan. It was obviously bullet-proof. Two big New York City cops flanked this door on either side. They were carrying guns.

Without stopping, the guy raced up, hit the door hard, and smashed his way through it. His energy must have been incredibly and obviously righteous, because those armed cops just stepped aside and let him through. He was bizarre in the extreme, he was like Godzilla, right?

"Yes sir, you wanna come in, yes sir, I'm not going to stop you."

He ran out of sight, still screaming.

All of a sudden, "Bam!" The outside door bursts open again.

This time, five elderly Puerto Rican ladies dressed in black come in carrying a baby. The baby is absolutely blue, can't breathe at all. Suddenly the guy emerges from the inner door, clutching a doctor by the throat. The women approach with the baby. He brings the doctor, and says to him, "Fix him!" They all disappear into a room.

Five minutes later they come back. They're all laughing and they leave.

Now, if this guy had come in there and done a New Age "excuse me ma'am, I have a baby here and he's blue," they'd say, "OK what's your social security number? Have any insurance? Where do you live?" They'd go through all that and the baby would die.

I watched the whole thing. The Emergency Room is the entertainment capital of the world. It's Charles Dickens in three dimensions.

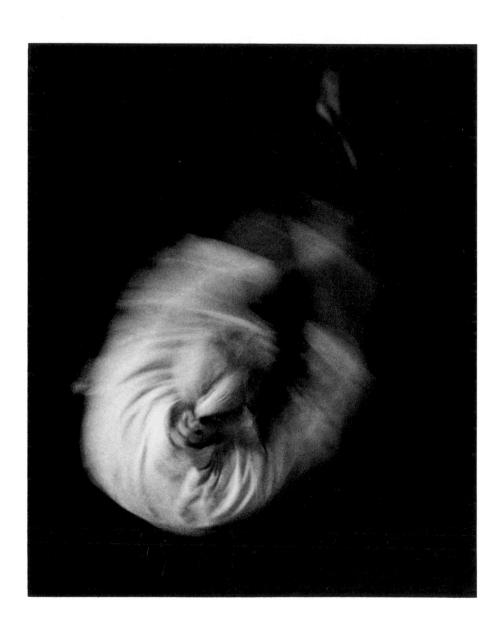

At no time do we sense energy more than when we are in love or in conflict. There is a heightened sense of awareness. A lot of the messages that you get and send out during conflict are in the medium of *ki,* or non-physical energy. I think it *is* physical energy, but we don't have a meter reading for it yet.

Chapter 3

I am calm, however and whenever I am attacked,
I have no attachment to life or death. I leave everything as it is to
the spirit of the universe. Be apart from attachment to life and death
and have a mind which leaves everything to that spirit, not only
when you are being attacked, but also in your daily life.

—Morihei Ueshiba Osensei

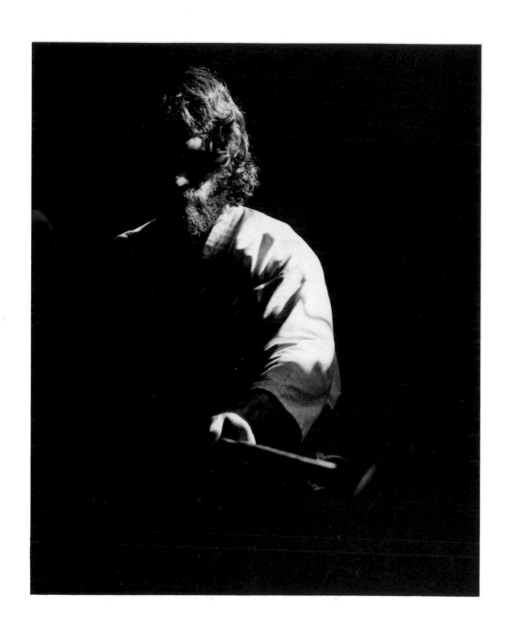

I think it was me who said, "You don't cut the man, you cut the devil out of his karma." Maybe I just can't remember who I stole it from.

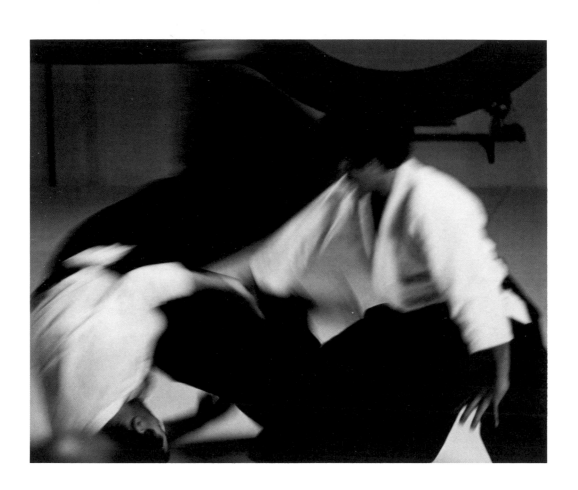

I don't know what a warrior is. You have to look at the basic defi-
nition of the warrior as someone who deals in war, in some form. It's
pretty bad, messing around with war. A lot of blood, a lot of guts,
really bad stuff. Somebody once defined a warrior as someone who
doesn't sleep in the same bed twice. That's one definition. Does that
mean that a hobo or drifter is a warrior? How about Arafat? He never
knows where he's going to stay at night, and that's why he has never
been assassinated. I respect him a lot for that. I don't know about his
politics or his ideas, but the loneliness that man has undertaken is phe-
nomenal. So how can I possibly discourse on what a warrior is? I don't
have the faintest idea. But I do know that I'm interested in learning
how far away I am from being a warrior. Not how close I am, but how
far.

I think one of the real dangers of the New Age movement is this word "warrior," because it's presented without dark side.

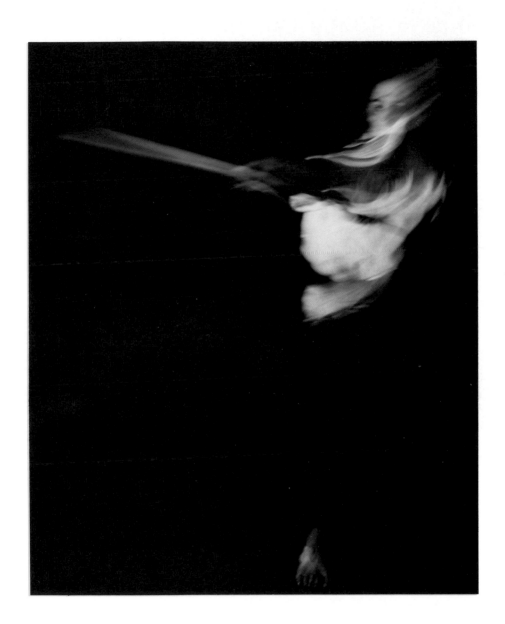

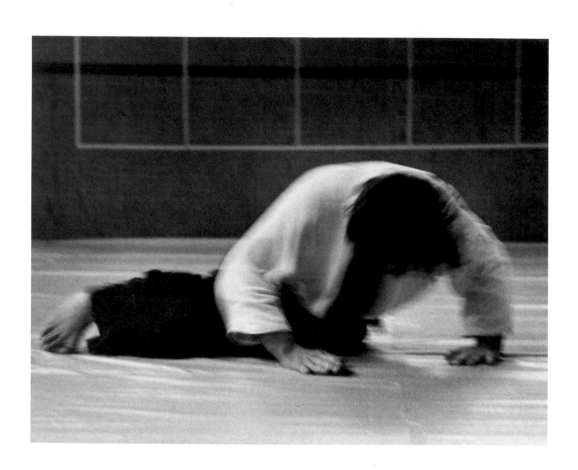

There was this guy at the Zen Center who was screaming; he was pissed off, saying, "God damn it, I've been working on enlightenment." James Hillman told him, "You shouldn't be working on enlightenment, you should be working on endarkenment. You're not ready for enlightenment." All of us in the room, although we didn't know the guy, knew this was absolutely true.

I knew a guy who was a senior student of many martial arts. He took me out to the country in the middle of winter to train. There was no room for us to stay in the house, so we had to sleep in the fields. It was very cold. In fact, it had snowed the night we arrived. It was much too cold to sleep. We were very tired and would occasionally nod off, but the cold would soon wake us up.

That night my friend was telling jokes, the stupidest, most childish jokes you could possibly imagine. We lay there, screaming with laughter. We lay in a field, three shivering bodies covered with snow, and it just seemed very right that it should be that way.

That is the way one should study, with the snow and the laughter. The two go together. If one of those things had been missing, there would have been something deeply wrong about it. It would be twisted, a masochistic or sadist pursuit. But somehow the laughter, the snow, the darkness, and the discomfort all mingled together to be very inspiring, very right.

The next day we were stiff and sore. I wished I were any place but there. My friend said things like "Hey, we've got a whole day to train yet." He knew exactly how I felt and so he would twist the knife a little bit. He said, "Should we go get some breakfast ? Or should we be real warriors and not eat anything?" I said, "Breakfast! Breakfast! I want some chocolate, I want some coffee, I want some ham!"

Of the warrior moments in my life, I think this was the great one for me. I sense that in some way I did make contact with warriors of other ages in that moment. Rather than anything having to do with battle or fighting or blood or anything like that, lying in the snow and laughing seemed to be correct.

I think great damage has been done by people romanticizing the image of a gentle warrior, a peaceful warrior, although I understand the intent. It's honorable. But I think we have to come up with another word. To use the word "warrior" in that respect is to confuse the issue. A "good person," "brave man," "courageous woman," these are better terms than "warrior."

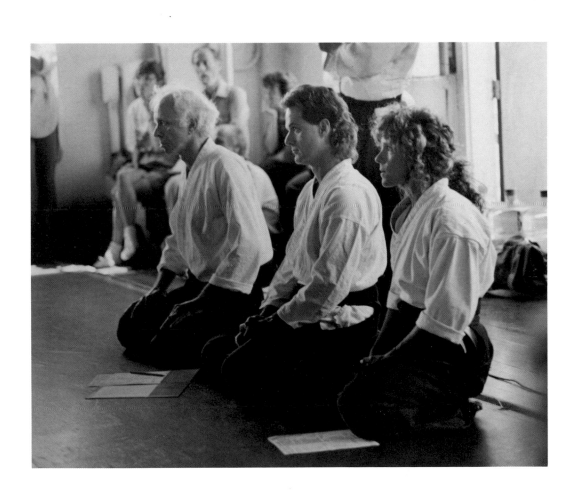

When I came back from Japan, I lived in my family's summer place in North Hero, Vermont. I got into jogging. I'd put on my *gi* and my *hakama* and I would jog up and down these Vermont roads. Neighbors used to think I was crazy. "What is this guy wearing a skirt for?" I would be carrying my *bokken* and I'd be feeling really butch. If there hadn't been anyone to see me, I am certain that I would not have gone.

Gradually, as the summer wore on, I got more and more crazy. I couldn't figure anything out. I didn't know why I was back in this country. Nothing was working. My wife and children were with me. That felt very strange. I felt more childish than my kids. I didn't know what to do about it. I had sudden fits of anger and I was getting worried.

I decided to go up on the mountain. These days, they call it a "vision quest." I didn't know that was what I was doing, but I knew that's what I had to do. I put on my heavy, army ammo pack. I took food, a stove, and my *gi*. It alone weighs eight pounds. On top of that, I lashed my *bokken* which weighs another eight pounds. So, I'm carrying at least sixteen pounds of bullshit up the mountain. I was going to meditate. God was going to speak to me. God was going to tell me what to do with the rest of my life.

Instead of hitchhiking, I got my wife to drive me over there. I even thought of having her drive me to the top of the mountain and come down, but I knew that was too much. You have to walk up yourself for a real vision. My kids had their eyes up against the window of the car. "Goodbye, Daddy, goodbye."

It started raining when I got out of the car. There was this whole humongous mountain to climb. I'd been up on the top before, but I had gone up on the electric car lift. It was steep, really a hard climb for me. It didn't stop raining, I mean it was really pouring. I thought that when I got to the top of the mountain, things would be better. Why I thought this I had no idea.

In fact, things were twenty times worse. The top of the mountain was one solid bog of mud. Everywhere I stepped was mud. I took two steps and I fell down. I had to pull myself up by the shrubbery, and when I did, I fell down again. So, pretty soon I thought, "The hell with standing up. Just keep crawling." I was crawling down the trail like a bear. And even then I'd slip. The mud was in my pants, weighing me down, in addition to the stupid pack with my *gi* in it.

In the back of my mind, I was thinking:, "Maybe there are some women up there, some hikers. That'd be really cool, me in my *keiko gi*." Well, there was nobody stupid enough to be up on that mountain in rain like that. I had to find shelter. I had a sleeping bag but no tent. I looked, and I finally found a small, rough cave with jagged rocks on the floor. I tried breaking the rocks off with my hatchet as best I could, then I crawled in.

I stayed in there for two and a half days, soaked by the rain. There was a little space where I could put my stove. God knows, I had plenty of water. I had powdered coffee, oatmeal, and granola. I would put it all together—the coffee, the oatmeal—and I would heat it up and stir it, add a little sugar and that was food. I lay there, two inches from the ceiling.

I slept there the first night. All the next day it rained. I didn't get out. My sleeping bag was wet, but it was warm. I slept there the next night. When I woke up the next day, it was still raining. I said, "Well, I guess God is not going to speak to me. He's been rained out."

I got all my stuff together, packed it up and started out. My *gi* was soaked and heavy with mud. So I was crawling along. The rain had made the trail impossible. I had a little map, so I knew where I was. It showed that if I went down a little further, there would be a trail off to the right to a cabin where I knew there was a fireplace and some wood.

When I came to that trail, I took it. It was rough going, too early in the season for the trail to have been cleared. I was crawling on my hands and knees for about a mile.

Then, the sun came out. It stopped raining. I thought, "Oh, far out. This is the way it's supposed to be. I made it through the worst part and now things are going to get better."

I came to a place where there were two pine trees. The trail went right through them. It also went around them. But somehow it went through them too. The rain had washed the soil out from under the roots of these trees. You had to be careful where you put your feet. I understood that as I was walking across. My pack, my big macho pack, and my big *tanren-bo* hit a branch. I looked up and tried to swing it, but I slipped and lost my footing. I fell. My feet were caught in between some roots and a thick branch snagged my pack.

The result was that I was crucified. My weight was hanging on my straps which were binding me. My hands were up, I couldn't get my feet out of the roots. I couldn't reach anything with my hands. I was stuck. The first thing I thought was, "Ha ha ha, this is a tough one. I'll just have to get out of this now." And I hung there.

Pretty soon the sun that was so nice to me a little while ago, became hot. I was all wet, and now I was steaming. I was starting to feel desperate when I saw something that made the hair stand up on the back of my neck.

There was a crow flying across in front of me. The crow looked at me, it really looked with intelligence. It could see that I couldn't move. I don't know what thought ran through the crow's head, but what ran through my head was that maybe he'd like my eyes. If he wanted to sit on my face and eat my eyes, there wasn't a damn thing I could do about it. I could yell, but that's about all. I was scared. Talk about fear. I could see that happening, birds pecking at me. All that

time, I had been saying to myself, "Don't panic. Keep your cool. You'll get out of this, just don't panic." I realized this wasn't working. I panicked. I went crazy. I was screaming, shrieking, twisting, doing everything I could, and finally I busted off the branch that was holding me. It was an old, thick pine branch. You know how hard they are? I guess I was more scared than it was. I managed to drop down.

When I saw the crow, I said to God—remember I wanted to come up to God and ask him what I was going to do with the rest of my life?—I said, "God, please help me. I need your help as to how to get out of this. Please tell me what to do." And God said, although I didn't exactly hear a voice but I got the message real quick, "Fuck you. Do it yourself."

That's what God said to me by return express mail. "You got yourself into it, you get yourself out."

I hiked to the cabin. Found a couple of ladies. Couple of guys. We had a nice party. I stayed there overnight. They said, "Man, you been out? What you been doing?" I looked like a mess. They thought I was some big deal. I didn't tell them the story.

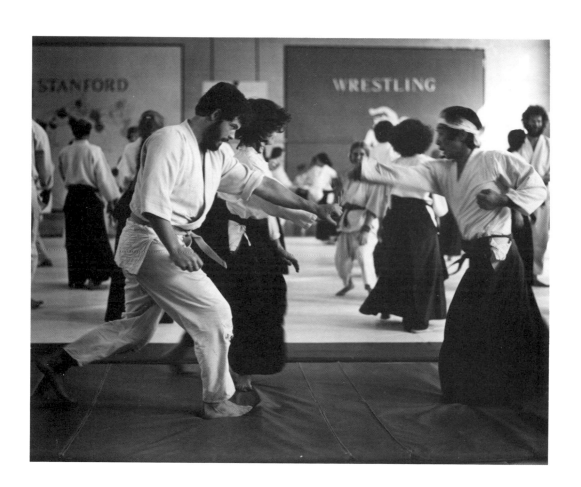

Early in the morning, in the main squares of small Spanish towns, you see old men walking along, talking. I didn't know what they were talking about and I don't think it matters. I could tell by the way they related to each other that there was honor there, respect, camaraderie. If there were more of that in our daily life, I don't think we would be so moved by the thought of going to war.

I think one of the reasons why this country goes to war so easily is because men want to get together in a way that affirms them. War is an easy way to do it. Start a war, everybody gets together, people help each other out. It's a wonderful feeling, a real expression of love. If our society offered more ways to affirm our love, we would not be so compelled to answer calls to war.

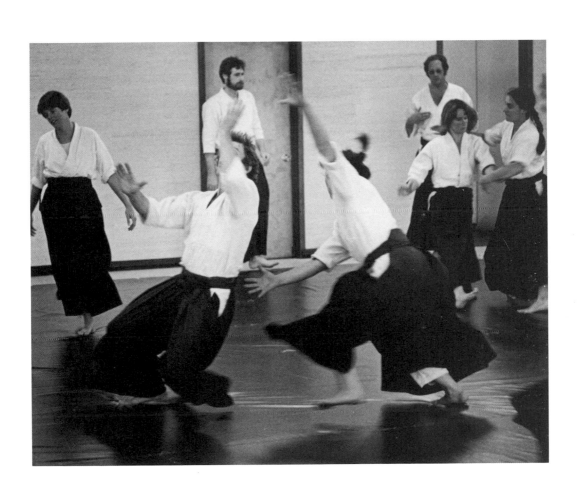

Francis Bacon said it back in the sixteenth century, "I know not why, but martial men are given to love." There is a close connection between love and war.

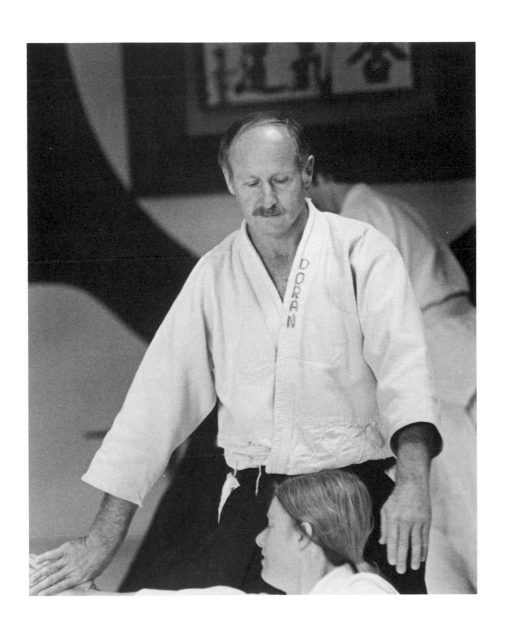

Chapter 4

I want considerate people to listen to the voice of Aikido. It is not for correcting others, it is for correcting your own mind. This is Aikido. This is the mission of Aikido and should be your mission.

—Morihei Ueshiba Osensei

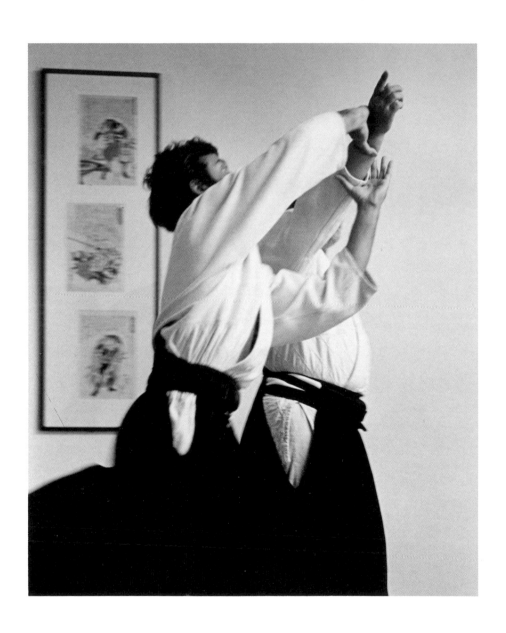

It's a lot like dancing. The more time and energy you spend on learning the steps, the less you'll enjoy the dance. At the same time, if you don't know the steps and you're all enjoyment, you're not very artistic. In approaching the art, each of us has to balance learning the steps and enjoying the music. Every teacher teaches in a different way. It seems to me that at the beginning, there's a preoccupation with learning the steps, and I think that's good. But later, it's important to know that the music is critical, too. Just feel the music and get into the feeling of the throw without worrying about the disparate parts. Participate in the flow. Eventually, you have to cut loose of the techniques and let yourself go. To do that is scary.

Remember that it's a martial *art*. Too often the word "martial" receives too much emphasis and the word "art" receives too little.

Auden defines the difference between Artist and Craftsman thus: A craftsman always knows the result of his labor, while the artist never does. I think in Aikido, it's a wonderful blend of both. You learn the craft, then you learn to throw away the craft and participate in the art.

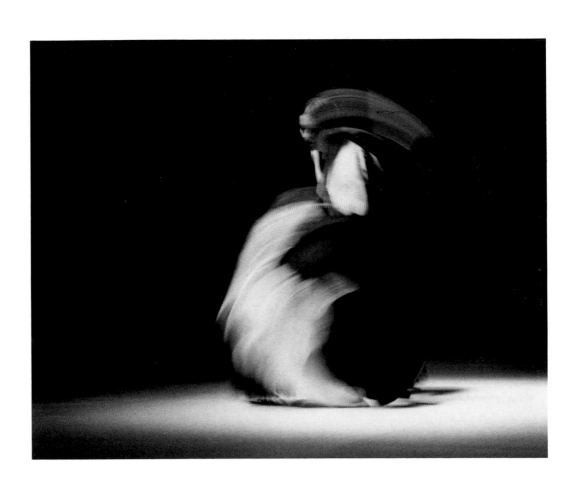

I once saw an incident on a little mountain spur railway that wound deep through the Japanese Alps, passing little hamlets of houses clinging to cliffs.

It was Saturday morning. People got on and off the train. There were old people going to market, farmers with their chickens and pigs, and a lot of college kids on a mountain-climbing vacation. The sun was streaming in through the window. Everybody was happy.

The college kids had their gear stuffed up in the baggage rack, mostly rucksacks with ice axes tied to them. They were singing German mountain-climbing songs with Japanese accents, which I found greatly amusing. Across from me was this beautiful old bald man dozing in the warm sun. When the train stopped, most of the kids got up to get off. One of them was next to me; he yanked his rucksack off the rack and the ice axe fell like a guillotine right into the beautiful old man's bald head.

I froze. The axe clattered to the floor. The old man woke up and clutched his head. Blood started squirting from the wound. He looked up at the kid, who was absolutely aghast. The old man saw that the boy had no idea what to do. He reached down, grabbed the ice axe, and handed it to the kid with a bow. He said, "Have a good day. Enjoy your climb." How is that for deep humility!

I hope that when I get to be that age and have an ice axe in my head, I'll remember to bow.

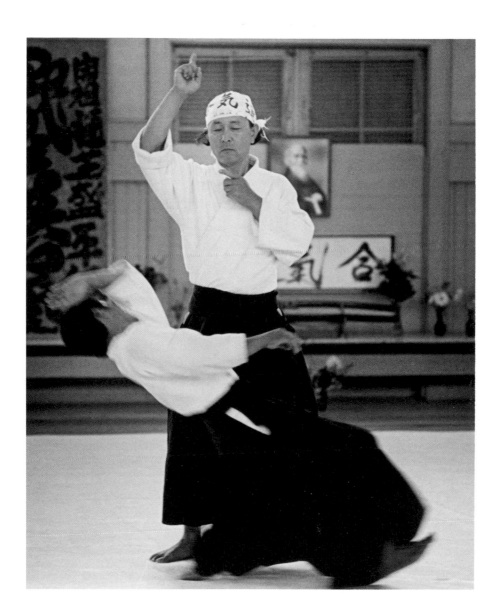

I didn't train in Aikido to become a teacher. I began to save my life. It never occurred to me that I would become a teacher. Osensei would say to me quite frequently, "You go home and you teach your people this. I want you to explain what Aikido is to the people of your country. We don't want war, we want peace. I want you to be a part of this." He must have said it one hundred times, and he said it to me privately. He never said, "Be an Aikido teacher," and I never thought he implied it, either.

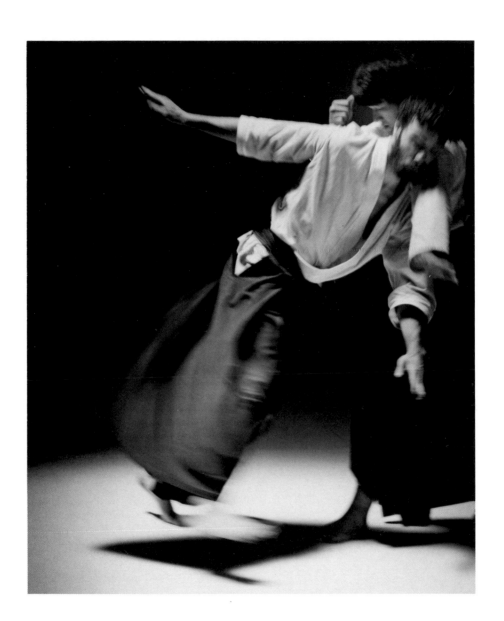

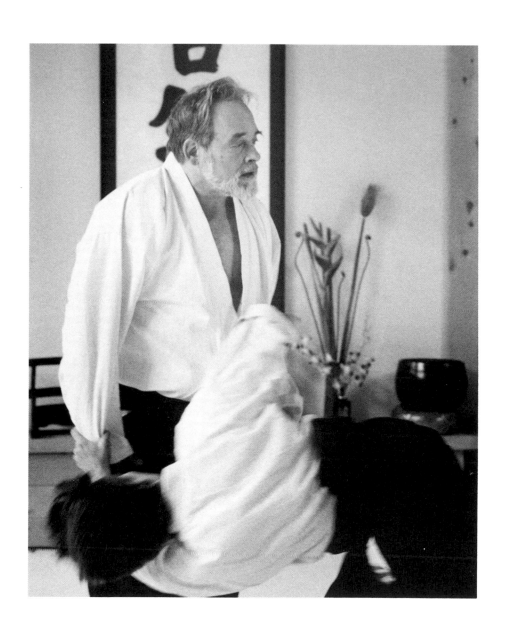

What is much more important than anything I say is that I touch you. Through me, through my touch, comes the touch of the founder of Aikido. There is no Bible you can buy that says, "This is what Aikido is." It is transferred from person to person. These vibrations pass among us.

Every time preparing for a workshop, I would have to start at the beginning. I would try to collect my thoughts in a logical manner. Then, I would go in and see all the people, and I would think, "Oh Christ, what am I going to do." Sometimes I would have no idea what to say, I would just start. I couldn't seem to avoid reinventing the wheel.

Eventually I began to accept that was the way it had to be in order for me to have an authentic presentation. It did have to be invented anew each time. Sometimes, my interaction with people would be very good, but it was because of a heart connection that happened despite my workshop. When it worked, it was for reasons I never intended. Somehow, the students would get something, and now and then, I would be invited back.

As I get sicker, I understand that when it works, it's a personal transmission. I have to go into a room with a bunch of strangers and somehow change the chemistry, change the vibration of the room so that birth and death become important. Usually it's a question of taking people and bringing them down. Many people resent being brought down because they think their struggle is to keep up all the time. So getting them down without resentment can be difficult.

If I'm not successful in establishing a heart connection, I'll have a terrible workshop. At some point in the workshop, people have to face the essential moments in their lives. Otherwise, it's superficial, a sort of floating thing. I keep working at it. I never really know what people get out of my workshops, because I don't know what happens to people when they leave. I don't waste much time on wondering about that anymore.

You are not an inert piece of stuff. You are a vibrating, charged, radiant being. There is a meeting between us. That's *ki*. As you reach out to touch somebody, your energy reaches out accordingly. I can feel it clearly. If you don't want me to turn your arm over, you can get heavy and there is no way I can do it to you. But I can get you to turn your own arm over. I do this by manipulating your *ki*. Osensei discovered this—that there is a way in which you can blend with energy in such a way as to use it. That was his genius.

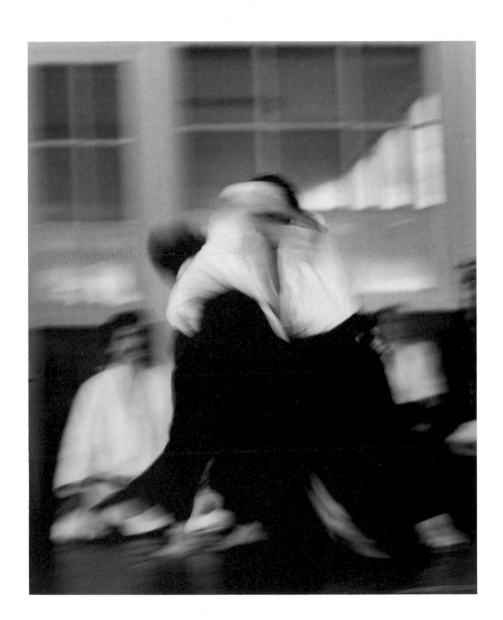

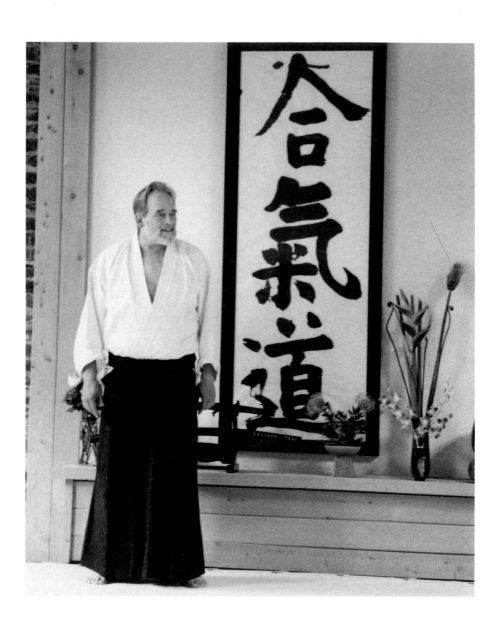

My friend Eric did management workshops in hospitals. He invited me to join him, probably because I was weird enough to spice up his presentation. The hospital we went to in Ohio was run by Catholic nuns who started out there in the 1920s. They're all ninety years old and there are no young nuns coming up. Nobody wants to work a twenty-hour day in a dead-end hospital like that. The nuns are old and set in their ways. But medical care has changed rapidly and the management has to change too. It has to become more efficient, which is not something the nuns are comfortable about. But they know something has to change and so they consult with a guy like Eric, who brings a guy like me along to spice things up.

I stand up to begin my presentation and I see that one nun in particular is looking at me really closely. She raised her hand. She said, "Excuse me, do you know your lips are blue? I want you to know that if you feel any chest pain, we have a coronary unity just down the hall." I said, "Thank you very much. Actually, I didn't know my lips were blue, but I do know I'm in heart failure." So, I started talking about failure.

After that, I started doing workshops around failure rather than success. I could start out as an expert, because I wasπ starting from my own heart failure. "I'm standing here in front of you as a living, expert witness to failure." It got their attention.

Intuition is what medieval people ascribed to angels. It's a quality of seeing and knowing at the same time. To see and to understand. If you are centered, you will not act incorrectly.

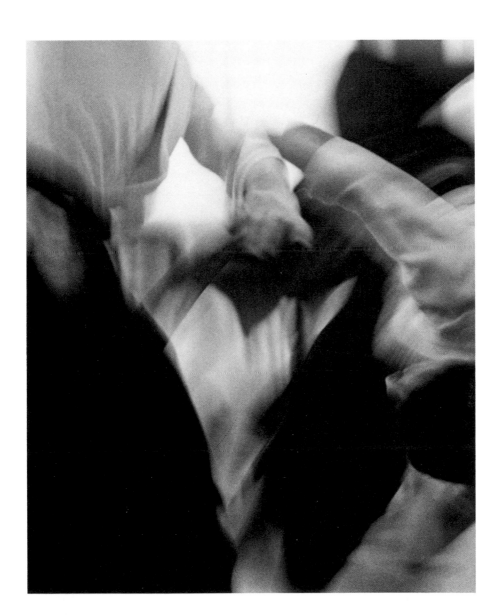

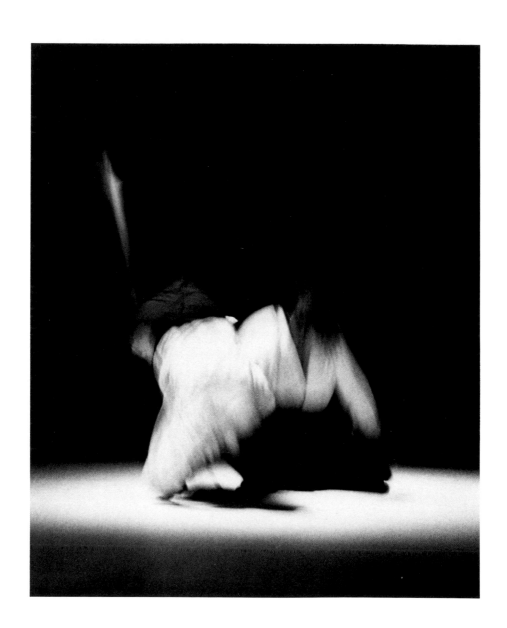

Sometimes I think intuition is an art that has to be cultivated, but at other times, I think it's just what you're doing naturally. You think you're operating rationally and that you're pretty slick and hip, but maybe we're all just intuitive beings anyway, and there's nothing rational about it. I'm interested in responding quickly. There are times we have to respond with speed. We have to learn to operate freely at speed.

I still don't understand circle, square, triangle. But I know these symbols can be very useful when you see them as the primary components of centered posture. In every organically whole thing, it seems that these qualities are present. There's a quality of centeredness which has do with being grounded, with *earth*. Even in our everyday language we talk about getting down, "hey man, let's get down." It has something to do with reality, with seriousness of purpose, with being rooted to the earth. With taking your stance. There are times when you should not get off the line, when it is absolutely imperative for you to hold the line in a way which is not aggressive, but is firm. Gandhi spoke of "firmness in truth." There is a remarkable component of courage that comes directly from your ability to take a stand and hold your ground.

Alone, this is not enough. There's also the component of *fire*. Your ability to be charming. Your ability to hustle. Your ability to laugh, to be humorous, to talk. These are part of the animating spirit, *ki*, the pulse of life, the incredibly subtle and pervasive element that is part of tact. The ability to know the right moment at the right time.

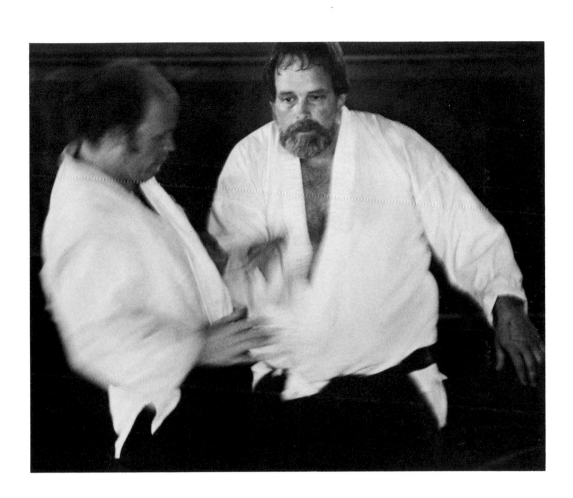

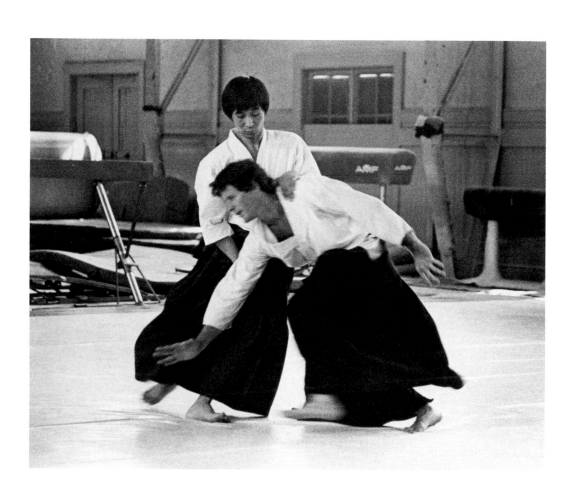

To be centered doesn't mean you have to be an angel, some bliss-ninny's idea of Mr. Clean. We're on this planet and we have to deal with life, with what's dealt us. For many people, certain buttons are pushed and they flip into an accusatory state. That's what most of us need help with. Deal with those buttons. If you stay centered, you don't have to respond like you always do when those buttons are pushed. The best way to do that is to stay connected to the ground. The statement "he's got his feet on the ground" refers to someone who is centered. When you are connected with the ground, you're able to deal much better with your anger.

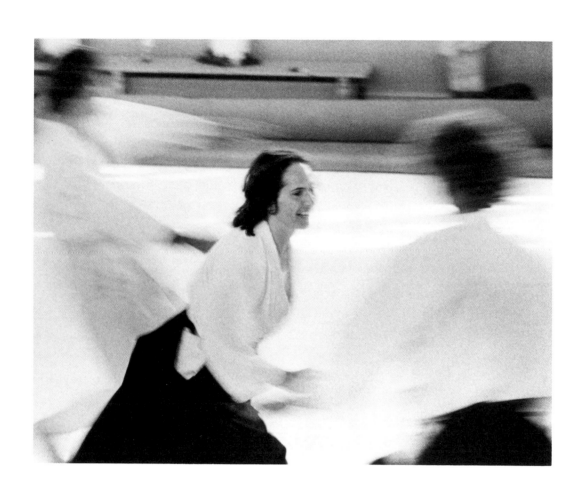

A woman is walking down an alley in a short skirt and high heels. A gang of guys comes down the alley and they start harassing her. She says, "Good evening, gentlemen. What time is it?" They all look at their watches and she walks on by. This happens all the time. When you get it together, this thing called "tact" comes through you.

Just because someone wants to have a conflict doesn't mean you have to agree to enter into it. Put the phone down and walk away. Get your center. Come back and say, "Sorry to have kept you waiting." This might drive people nuts, but it's legal.

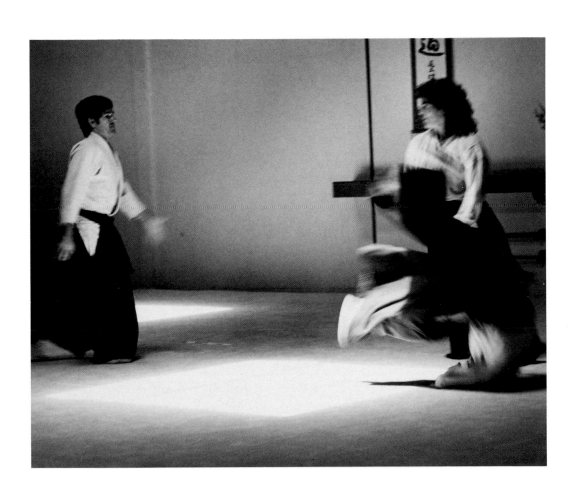

Tact is the ability to do the right thing at the right time. How do we know how to do this? How to be tactful? You can't decide to be tactful. You can only do it intuitively, when you are fully engaged, when your spirit is collected or synchronous. Tact comes from the Latin word *tangere,* which means, "to touch." In Aikido, we touch each other physically and spiritually. In this way, we are learning to open ourselves up to tact, to saying and doing the right thing at the right time.

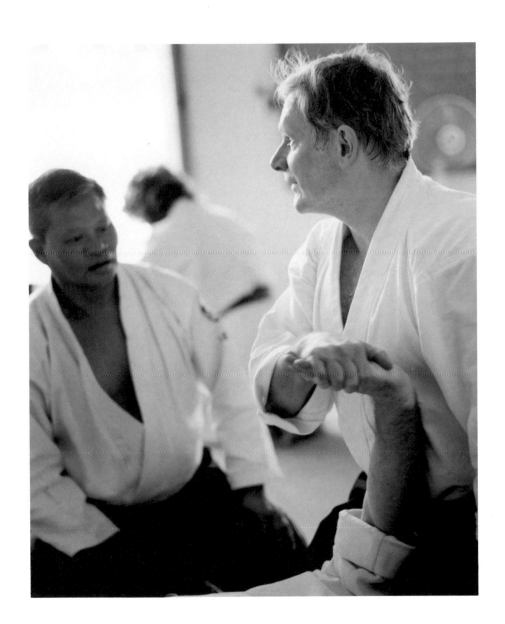

There is a wonderful line by Raymond Chandler: "Down these mean streets must walk someone who is not himself mean." I felt myself being evaluated by Osensei in that way. Unfortunately, I'm too mean to ever fill the role of "chief," but I appreciated that he was looking for that quality.

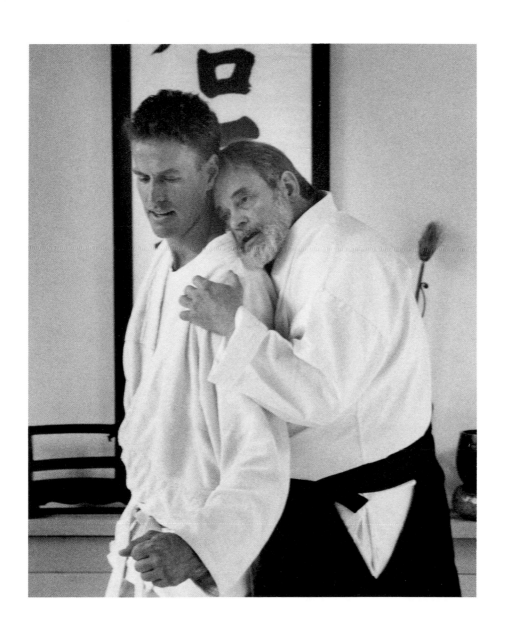

Chapter 5

Don't look at the opponent's eyes, or your mind will be drawn into his eyes. Don't look at his sword, or you will be slain with his sword. Don't look at him, or your spirit will be distracted. True Budo is the cultivation of attraction with which to draw the whole opponent to you.

—Morihei Ueshiba Osensei

My teacher used to teach us to look between the eyes instead of into the eyes because you can become enthralled with the beauty of the other person and be unable to deal with his attack. This other person might not be as refined as you are. All he will see is a sucker who has fallen into his eyes and he will take your head off. So, if you have the ability to see another person's beauty, you have to avoid becoming a prisoner to it. Look between his brows.

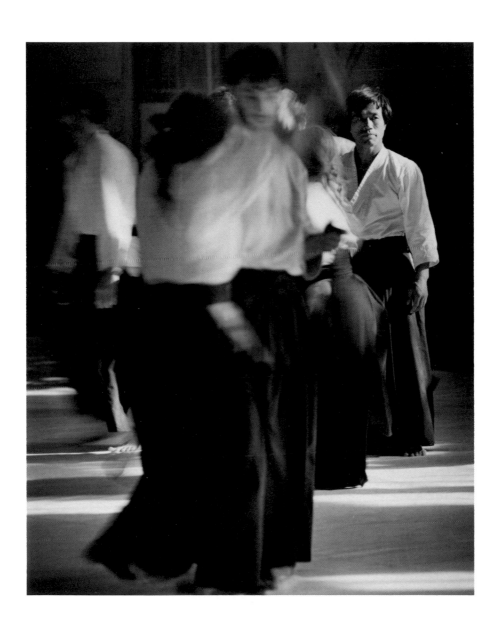

Soon after I came home to North Hero in 1984, I crashed into a cow while driving. When people asked, "How have you been?" and I said, "I just hit a cow," they thought it was very funny. There's something very comical about hitting a cow, but by God, you try it! You try hitting a black cow, driving down the road at fifty miles an hour, lawful speed, in a '55 Ford pickup truck. Going down a black road covered with black ice. Black macadam, black night. I saw a man waving his arms at me. I saw that he was warning me about something, but I couldn't see what it was. I started to put my foot on the brake and just then I saw the cow. The cow was right in front of the truck and I hit it.

I saw the cow's eye and face as her head snapped around and she looked at me. This thought popped into my mind: "Born in the year of the Ox, am I thus to be cowed?" I was so amazed. I could very easily have been killed in this car crash. Many people are killed by animals every year. There was some part of my brain that didn't care if I had gotten killed or not. It was just filled with comical, critical remarks. My brain was having fun, it really doesn't care if I live or die.

Deer use their antlers only in social combat. Those great horns are used only for a ritual attack. When they want to actually fight off predators, like wolves, they use their hooves. It's the same thing with piranhas. When they fight between themselves, they don't use their teeth, they use their tails.

So these great antlers that weigh sixty to eighty pounds are only for show, for sport. They are very important—the bigger they are, the more powerful the male. Our Defense Department could learn from this. Weapons don't actually have to be used, they need only be flaunted to show power, in some kind of ritualistic way. I was just ecstatic when I learned this, I think it was the most exciting thing I ever read.

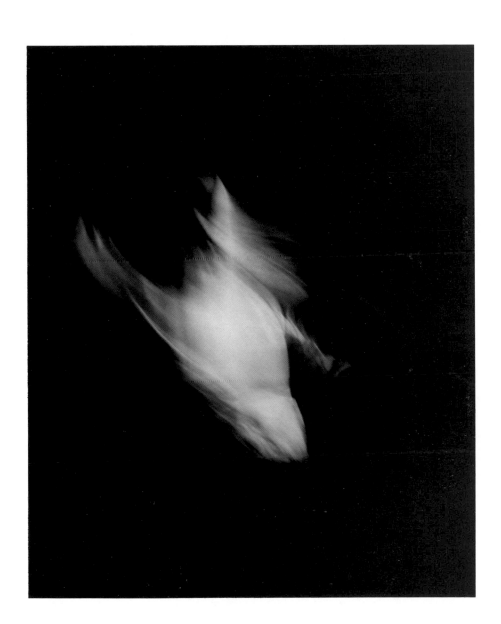

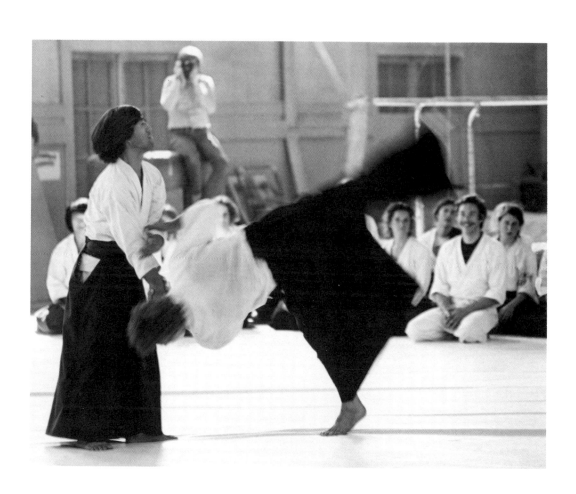

I hate the samurai. I think the samurai suck, and you can quote me. It's not that they were without virtue, or nobleness. But they didn't have a lot of heartfulness. One of the first steps to being a samurai was to get beyond love and grief. All this romance about samurai life ignores the fundamental truth that it was a very heartless existence. Japan gave us this wonderful art of Aikido. It gave me my life. But you have to be judicious about it. You have to include the heart stuff. Realize that what you're dealing with is a warm, live human being whose body and spirit may be easily hurt, easily crushed. You must throw another person in the context of love. This is hard to do, especially when you've had a lousy day or when you owe back taxes. So you must continually come back to the fact that there is no separation between you and the other person.

A certain kind of person, usually male, tends to approach Aikido from a competitive, quantitative viewpoint. "If I study twenty minutes per day, it will take me ten years to get good. So if I study an hour a day, it will take three years. If I do Aikido for twenty-four hours around the clock, I'll be a sixth *dan* in four months! Go!" It has nothing to do with any of that. When I started, I came from an American male competitive background. I was going to "get it." Now I figure that there's just no "it" to get, so I'm in no hurry.

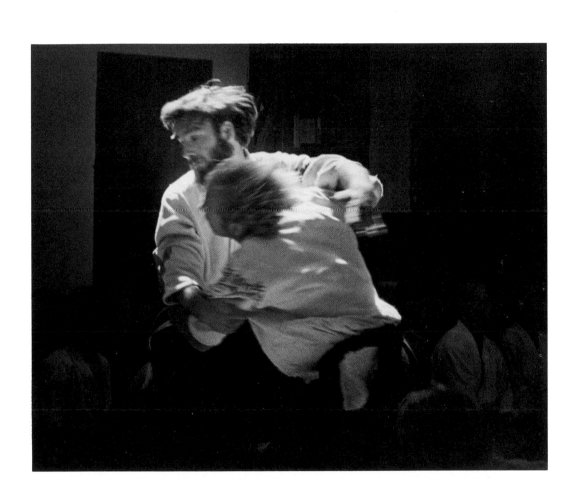

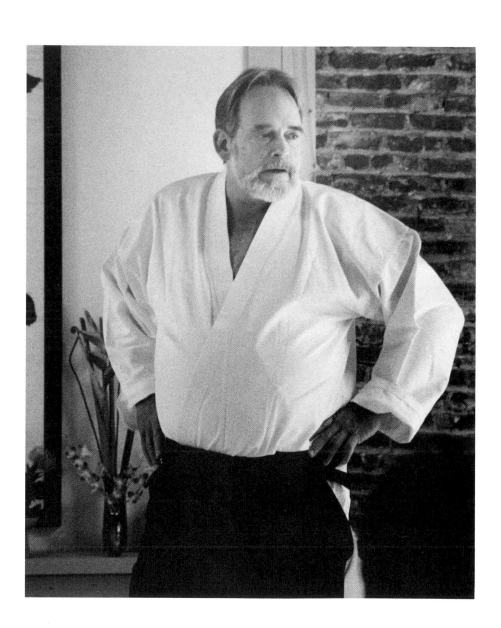

I was raised a red-blooded American boy. Because of my size, I played football, where I learned that the guy who swung the biggest hammer got the most accolades. If you hit a guy hard, you were rewarded with strokes and adulation, and I wanted the strokes. If I didn't get them, I'd bear down harder. Finally, during my high school career, I hit a boy during a tied game, in an undefeated season. I broke his nose, teeth, cheekbone, jaw, and a few other things. At the end of the game, as I was being congratulated about how good a boy I was, how great a game I had played, I saw the ambulance coming to take the kid away. I knew I had really hurt him. I felt a mixture of great pride and deep shame.

This contradictory feeling really puzzled and upset me. If I admitted my compassion for the boy, I would be going against the very system that was giving me the emotional rewards I wanted so desperately. Later on, I worked out with the New York Giants. Vince Lombardi, the line coach at the time, was the apotheosis of the heavy hammer school. His famous quote was, "Winning isn't everything, it's the only thing." To be a good player, I tried to erase my feelings of compassion and shame. It was only through Aikido that this contradiction began to be solved for me.

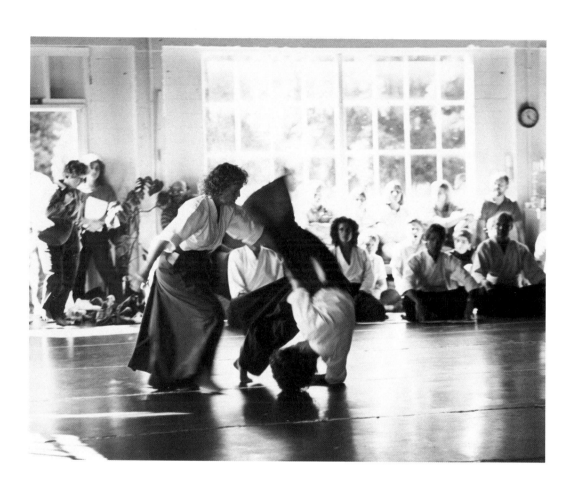

I think it's dangerous to talk too much. There's something I can learn from you. I'd rather listen to your war stories than rehash my old war stories, and you'd rather listen to mine than tell your own. I can understand that. So why don't we call a moratorium on the war stories entirely, and instead talk about how we are going to get out of this mess. How are we going to change our lives? How are we actually going to do it?

I spent ten years getting my ass kicked by Japanese people who weighed one-third of what I did. My most humiliating experience was when I worked out with a man who weighed about 105 pounds. He said his specialty was on-the-ground matwork. I asked him to please show me some stuff. He placed one thumb back in my collar, and put the other on the tail of my jacket. He said, "OK, do your best."

I tell you, I used my arms, my legs, everything I had, but I could not get that old man off me. Now, I tried for a full five minutes of full-scale activity. I couldn't even turn over. I was lying on my back. I bucked and twisted, squirmed and flailed. I couldn't get out from under him. I look at you people and there's not one person I fear more than anybody else. Size or sex have nothing to do with it.

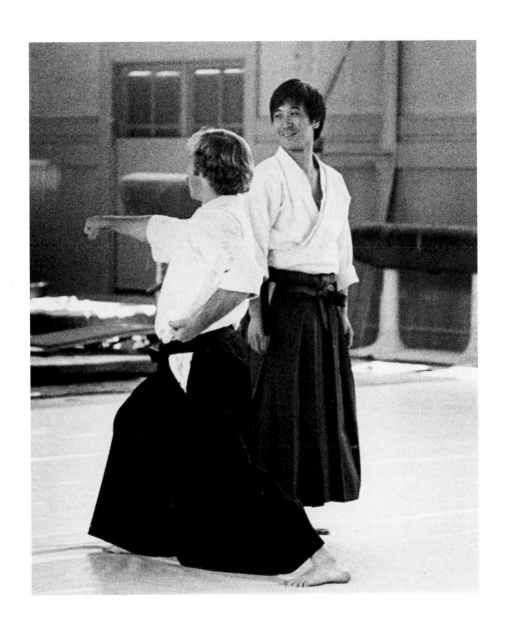

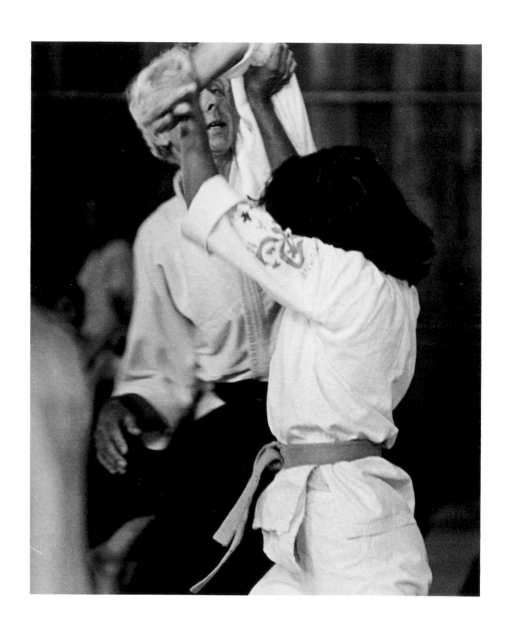

Once I was sobbing on the mat because this old man refused to do things the way I thought they should be done. Because I was a beginner and because I thought there was one way to do it. And by God, he wasn't doing it well.

If I had one piece of advice for beginners, it would be to forgive yourself on the one hand, and to be strong enough on the other to accept your grace. Some students quit right after they learn how to roll. Learning how to fall, to roll, is just a basic thing. The fear of falling is primary. Learning how to roll is to come up tight against that primary fear. Once you learn how to deal with a sudden loss of support, once you build a certain structure for dealing with that, there is an influx of power, a feeling of competence. If you can't deal with that power, it's a sudden shock to your system. Paradoxically, people often can't deal with that sudden rush of good feeling, and they don't come back. They feel guilty about having dropped out when they were doing so well.

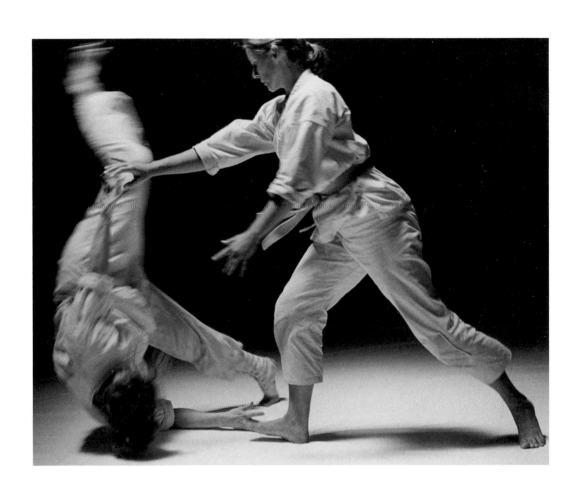

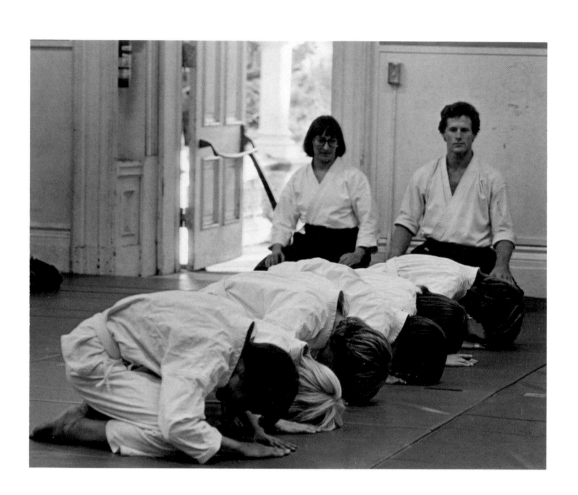

One reveals oneself in the way one bows. In the Aikido dojo, you bow when you enter and when you come onto the mat. The spirit in which you bow is very important; you reveal yourself by the way you bow. An empty bow, while better then not bowing at all, is essentially worthless. As you bend at the waist and at the neck, you want to experience a feeling of vulnerability and humility. Your bow makes you an empty vessel into which knowledge can be poured. I used to be a terror about bowing; I would throw a student off the mat for an empty bow. It happened to me once.

One teacher caught me in a flippant bow and hauled me up for my arrogance. He refused to let me finish the class and sent me off in disgrace. It took me about three weeks to get over the embarrassment and go back to class. You can bet that when I did go back, I tried to bow as deeply and sincerely as I could. One time I drew a bow that had to be a world-class bow. I was right there. My whole spirit was right there. When I came up, I saw him give a smile of satisfaction which he tried hard to conceal.

If you bow well to a partner, to somebody who doesn't know you, that person will immediately become fully conscious of you. The bow is really the soul of the art. Too often beginners think it legalistic interference, some kind of quaint custom that has to be gotten through quickly.

You bow when you get on the mat. You bow to your teacher every time he comes by and says something to you. You thank him. You thank your partner for any instruction given to you. Should you unconsciously be the cause of injury to another person, bow to them. Should another person cause you injury, bow to him as well. Thank him for the experience. When in doubt, bow.

When you go into the dojo, bow towards the *tokanoma*. That is the place where God dwells, where the soul of the art dwells. You acknowledge that the instant you walk through the door. You should be on full alert, relaxed, not tense. You should be aware of what's going on around you. You remain in that state until you leave, better still, until you get home.

Entering some dojos is like falling into a pit with fifty cobras who are sunning themselves. You don't want to make any waves and rile the cobras. Just go about your business quietly. You sure don't want to feel at home. You are stepping into a different world. The world of Aikido is black and white. Life and death. You should be aware of life and death the moment you get on the mat. Not to do so is to invite injury.

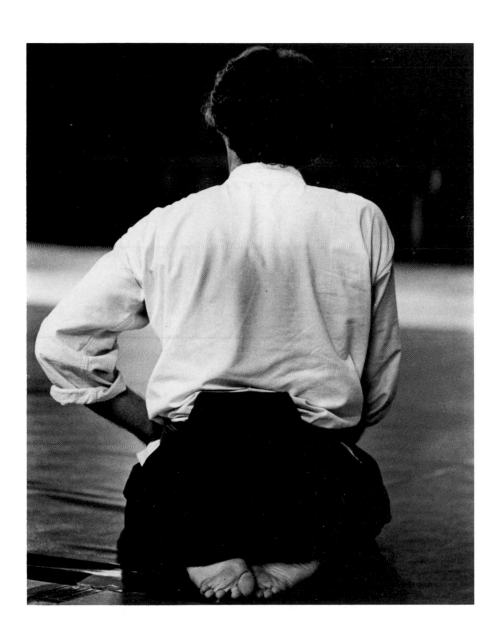

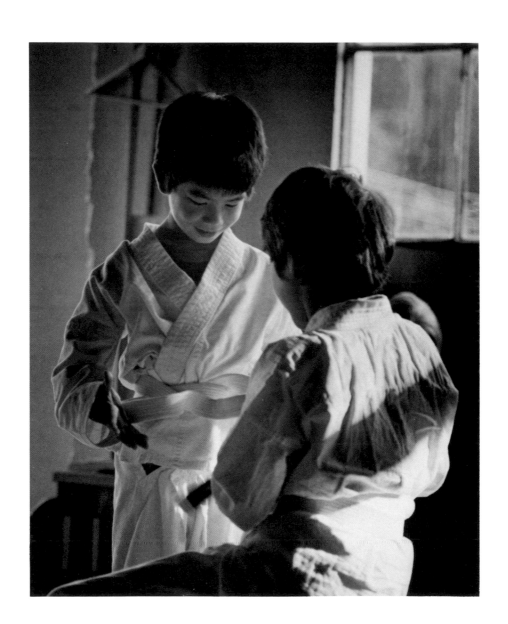

I am a stickler for the belt. It's more than something that keeps your pants up, it's a significant thing, it's closure. You tie it in a knot that is symbolic of the other closures and knots you make with the techniques learned in class. There's a right way to make that connection. I can tell the general nature of what someone does, whether or not they use their body a lot, by the way they wear their belt.

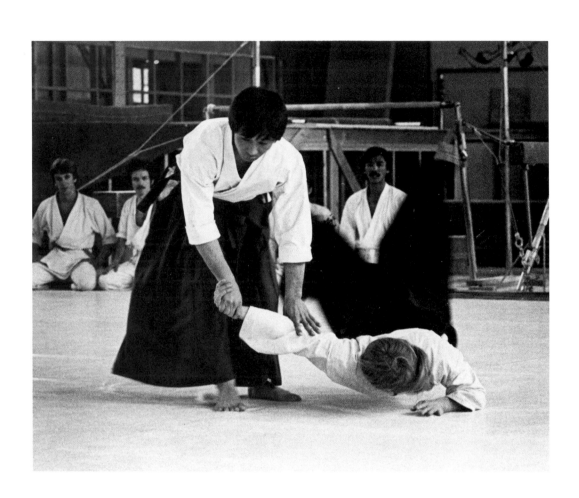

In Japanese, the word *Nage* means "to throw," and the word *Uke* means "to accept." The *Nage* is the one who gets to throw the *Uke*, who agrees to be the fall guy. The *Uke* has to accept the basic premise that whoever attacks is already defeated; by attacking, he has already lost. You learn more in Aikido as an *Uke* rather than as a *Nage*, because you learn to accept what is going to happen to you with full commitment.

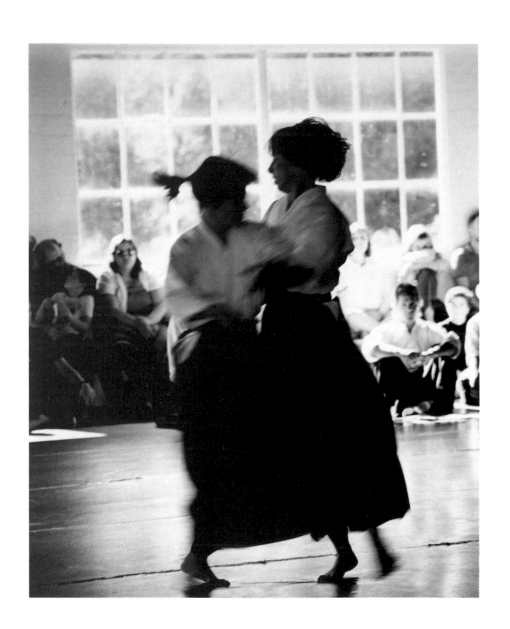

The word *ma-ai* in Japanese means "space-time." Try to keep at least a distance of the length of two arms when dealing with strangers in the street. You take a step towards me, I take a step backwards to maintain this distance. I've spent many hours dancing around at this distance just to learn how far that really was.

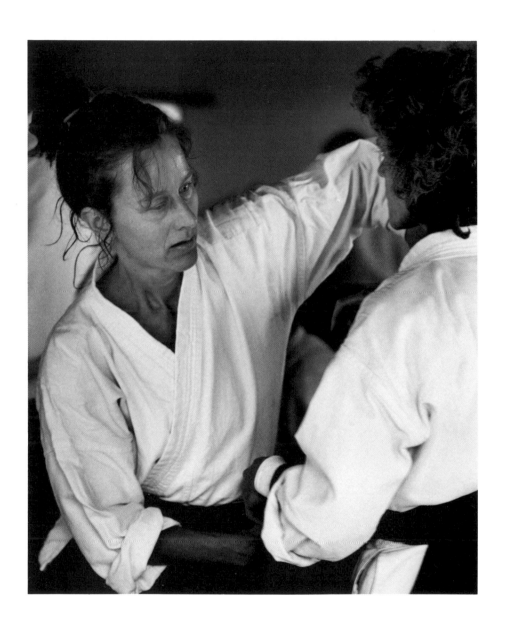

By holding up your hands, you have reduced your vulnerability to the other person. You shade your heart. When things cool down, you can open your heart to the other person and get it together.

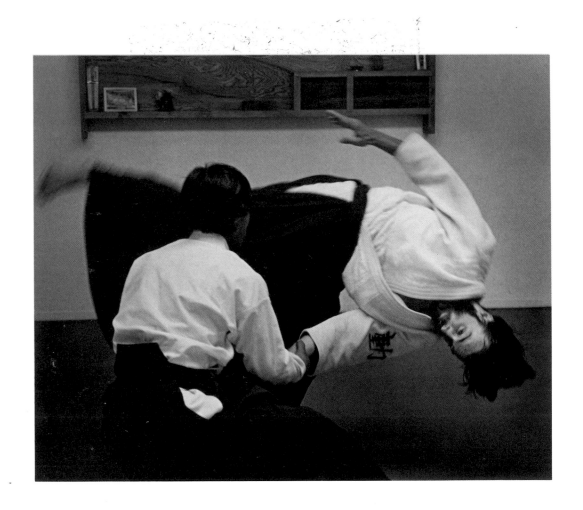

Maybe the reason you can't roll is because you can't leave your feet. You can't go for it. You can't trust enough to just jump the hell out into space. Ultimately no one can do that for you. If they kick you out of the airplane, it was not your decision to jump; you were robbed by allowing somebody to do that for you and you participated in your own robbery. Once you make the decision to go for it, it is dynamite.

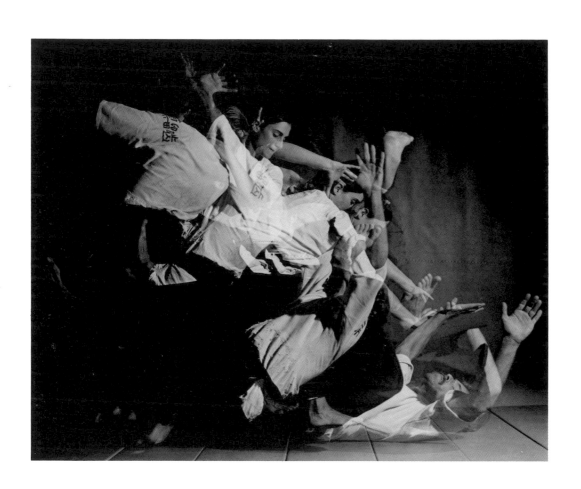

When you end the technique, make sure that you remain totally present. Surround your partner with your presence. You want to ensure that he has not been injured. You are responsible for his well-being, you are his protector. There's nothing that hurts more than causing injury to someone else. You feel like a fool. It's one thing if you are taking care of business and something happens; well, it wasn't your fault. But if you were looking out the window, saying goodbye to friends, and as a result of your inattention your partner came to harm, you know you've done wrong and you have to watch that person suffer.

I was in Japan talking to a Japanese guy who I had gotten to know well on the mat. One day he said, "Oh, my left arm is killing me. I hurt it." I noticed that he had put a bandage on his right arm. I said, "Hey man, I thought you said your left arm was hurt. Here you are putting a bandage on your right arm. What's going on?" He said, "Oh, I always do that." I said, "How come?" He replied, "Haven't you noticed that if you tell someone you are sunburned on your back, he will almost always slap you on the back? And if you have hurt yourself and have bandaged it, someone is bound to come and grab at that place. People sense injury. It's an unconscious thing. So when I injure my left arm, I put a bandage on the right. People will come and hammer on my right arm and then my left arm is safe." That seemed to me to be so weird, it had to be right on.

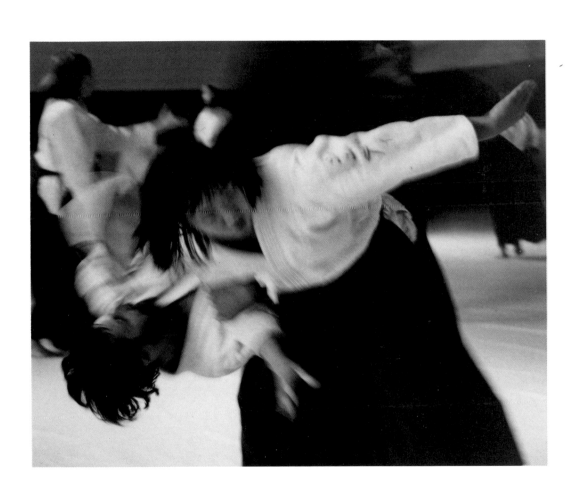

Some people can change their lives drastically through Aikido. I'm sure that incredible things also happen to people who windsurf. It's stunning, the power that people have to transform themselves. But it is important to remember that Aikido is not croquet.

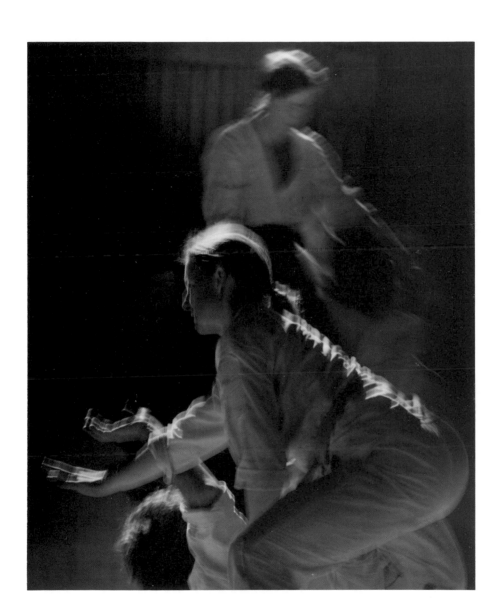

A blacksmith friend of mine went to an ironworkers convention at the Boston Museum. The program included a demonstration by a group of Japanese blacksmiths. The meaning of, "blacksmith" is someone who works in coal. You use coal to heat the fires to melt steel; it is a very dirty occupation. In Japan, the blacksmiths put on white clothing in the morning. They work fast, they get the job done. At lunch time, they clean everything up, put everything away, go off and eat lunch, and come back. They start everything up again, start the fire again. At the end of the day, their white clothes are still white. My friend, a talented blacksmith, could not believe this. He could not imagine himself working with coal and keeping clean. He said that at the demonstration, there wasn't any dirt on the floor—the whole place was clean.

When you experience another culture, you see something and you say, "I want to learn how to do that." Well, first you have to learn how to keep your clothes clean. You might think, "Why should I learn how to keep my clothes clean, I got a washer-dryer, I'll just throw them in the wash." So you have to give up your washer-dryer. It's not just simply a question of learning the alphabet. It's the whole gestalt that has to change. Sometimes for the good, sometimes not so good.

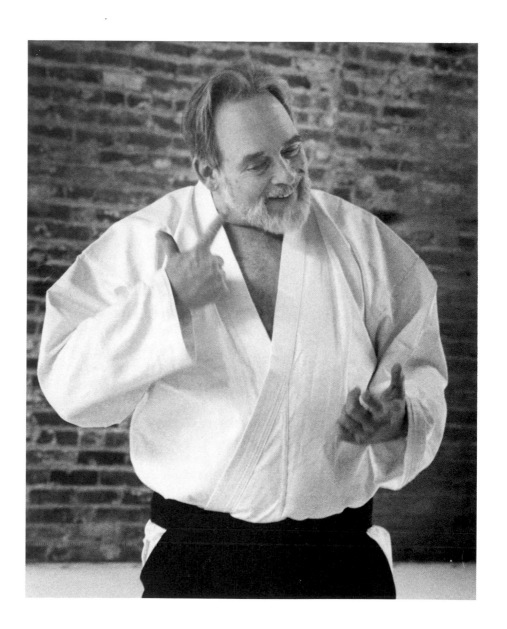

I've done a couple of things that any reasonable six-year-old would have known was going too far. I learned that not coming up against your edge is bad, but going over it is terrible. What you want to do is gingerly approach your limit. Go up to the edge and go no farther.

Chapter 6

Aiki is not a technique to fight with or defeat an enemy. It is the way to reconcile the world and make human beings one family.

—Morihei Ueshiba Osensei

My parents were divorced. My mother remarried a man who had two sons who were both older than me. Those kids hadn't had much discipline for a variety of reasons. Their father had been overseas in the war, their mother had died, and they had gone to live with their grandparents who didn't know how to restrict them. When they moved in with me, I was a fat, dreamy, seven-year-old kid. I didn't know anything about fighting. I had to learn quick, and it started right at the airport. They beat me up every day. It went from being a family where I was the man of the house, to a family where I was now number four in terms of the male pecking order.

I used to torture my mother by decorating myself with all these weapons. I had knives, guns, whips, hatchets. I had knives in my boots, I had brass knuckles. I had every possible weapon you could imagine. I used to make my own bombs, hand grenades, and poisons. I lived entirely in a world of mistrust and warfare. I was filled with hate.

There is a picture of me from that time. There's a whip wrapped around my neck and weapons dangling everywhere. I look completely hostile, I am negative space incarnate. I wasn't putting that look on for the camera. I was twelve years old. Somebody wanted to take that picture. They said, "Go get your weapons." And I did. But I was pissed that I had to interrupt whatever I was doing to be there.

It is very interesting to me that I did not become a serial killer.

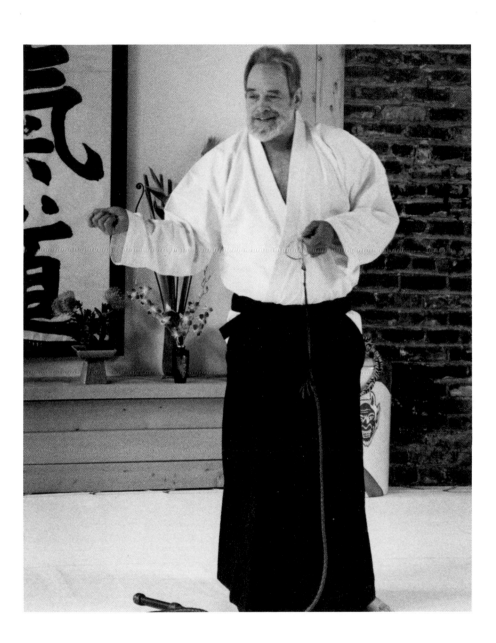

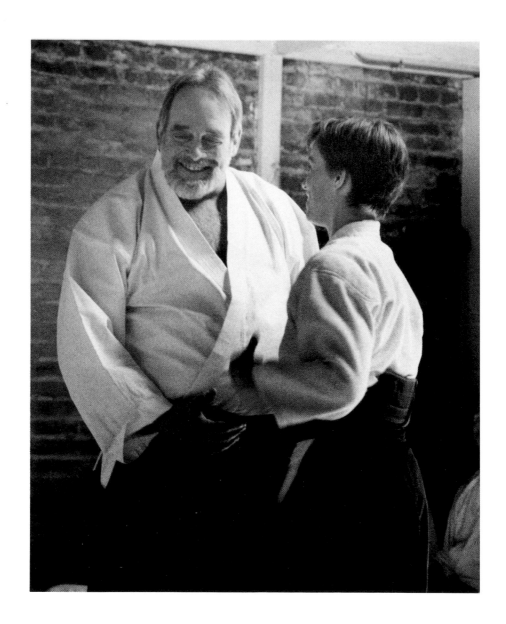

The purpose of conflict is harmony.

Epilogue

Terry was in great spirits despite his terrible health when he traveled out to California in August 1992. He taught for ten days at the Mendocino Men's Conference and stayed to conduct Aikido classes in San Francisco and Point Reyes. Right after his last class, the night before he was to come back to Vermont, he suffered a cardiac arrest and collapsed into a coma from which he never emerged.

Much later, when I finally got to California, I was told that his teachings had been radiant, his spirit translucent. I heard he had looked exhausted, that he had heart problems, that he could barely walk. As the days went on, it became clear that he was going to die. And that he was choosing his own way to do it.

We took him out of the hospital. He lay on a redwood deck, under the sun, surrounded by family, friends, lovers, students. We were able to dress him, wash him, and help him on his way with ritual and poetry and grief. His dying was a dialogue into which he generously allowed us to enter; he always loved a good audience and we were right there with him, learning how to do it, what it was, how to survive. We were in his last story and it created itself just like all the others had, with these wonderful qualities of marvel and wisdom that were Terry's gift to this world.

<div style="text-align: right">

Riki Moss
July 1993
North Hero, Vermont

</div>

Terry Dobson Biography

1937 Born on June 9 in Cambridge, Massachusetts.

1940 Family moves to New York City.

1945–1952 Attends the Buckley and Harvey Schools.

1952–1956 Attends Deerfield Academy.

1957 Attends Franklin and Marshall College.

1957–1959 In the U.S. Marines.

1959 Returns to New York, attends NYU Film School, has odd jobs as chauffeur, waiter, industrial spy, etc.

1959 Goes to Japan to work in a private, rural Peace Corps-type operation.

1960–1969 Studies Aikido at Humbo Dojo.
Teaches English, has jobs in various import businesses.

1962 Marries Tomiko Morozumi.

1967 Has two children, Marion, born September 10, 1964, and Daniel, born August 31, 1967.

1969 Osensei dies.

1970 Leaves Japan for Hawaii.

1971 Lives in Newport, Rhode Island.

1972 Moves to New York City, trains at 18th Street Dojo.
Also starts a dojo in Burlington, Vermont.

1973 Founds the Bond Street Dojo with Ken Nissen and Kini Collins.
Has a moving business in New York.
Starts going to workshops in California.

1979 Moves to San Francisco, California.
Does workshops and teaches in various dojos.
Begins teaching with Robert Bly.

1984 Moves to North Hero, Vermont, the family summer residence. His illness begins, and he stops doing Aikido.

1985 Moves to Grand Isle, Vermont, with Riki Moss.

1987 Starts teaching at the Burlington, Vermont, dojo. Continues doing a few workshops at Omega, the Mendocino Men's Conference.

1988 Travels again, doing workshops coast to coast.

1991 Has a heart attack and undergoes surgery.

1992 Goes to California to teach.

1992 Dies on August 20 in Point Reyes, California, of cardiac arrest.

Acknowledgments

To Terry's children, my family: Marion Dobson Deforest and Daniel Dobson. To John Deforest and Kitty Shapiro. To Brother Ray.

To David Gamble and Nancy Bertleson, who opened their hearts and home so gracefully. To Sandy Jacobs for those incredible tapes. To Rhiannon who pulled all that grief up from the earth for me and settled it so softly down by my side.

To Jan Watson for her strong vision, her guts, and her determination to get this thing off the ground, no matter what.

To North Atlantic Books for supporting our ideas of beauty.

To Martin Keogh, Michael Mead, and the men in the Mendocino woods who provided Terry with the company of poets, to Malidoma Some for that river of tears, and to Jack Kornfield who always appeared exactly at the correct moment.

To Robert Bly, Terry's most elegant dancing partner.

To Abbot Cutler, Ed and Jane Pincus, and Andy Bryner.

To my sister in soul, Dawna Markova.

To Jimmy Bone, Hank, Neal, Kevin, Gail, Janet, and Dana and all the other Aikidoists who took part in Terry's stories: the students in Burlington, California, Wisconsin, Toronto, Montreal, Ottawa, Oregon, Washington, DC, Baltimore, New York, New Jersey, Sarasota, Miami, Montana, and New Mexico.

To Tim James for his beautiful hand-bound memorial book for Terry.

To Kaz Tanahashi for his invaluable support in getting Terry to talk. To Ellis Amdur, Kini Collins, Stu Spingarn, and Ken and Jane

Nissen. To Dan Chow and Judith Shepherd; to Terry's brothers Buzz and Rennie. To Cousin Tom, Liz, and Tucky. To Peter and Laurie.

To my patient, loving parents, Bill and Lenore Moss.

The generosity of these people, sharing themselves as they supported me through this time of upheaval and mystery, simply takes my breath away.

<div style="text-align: right">

Riki Moss

July 1993

North Hero, Vermont

</div>

The camera came to me twenty-three years ago when Peter Henricks hired me to work at Woodside Camera. There I met and shared a photographic studio with David Krauss, who introduced me to Rob Swigart, who asked me to photograph his Aikido blue belt test. I watched this beautiful moving form for two months before I stepped onto the mat and when I did, knew I would be doing this for the rest of my life. Fourteen years later, the mat still gives me great delight and constantly tests me visually and physically.

I want to acknowledge my Spirit for leading me through the maze to my friends Peter, David, and Rob. I thank them for being my guides and Peter and David for their continued friendship, technical advice, and belief in my work.

My ongoing gratitude to Stanford Aikido, Aikido West, Aikido of San Francisco, Tamalpais Aikido, and Aikido of Point Reyes, where I've trained through the years and my camera laid its eye on these beautiful spaces, and the people who train and appear throughout this book. I would especially like to thank Mary Pouland, Arron Reises, Malcom and David Brown, David Hurley, Marilyn Anderson, Foster Gamble, Elaine Yoder, Sue Ann McKean, Carol Sanoff, Cheryl Rein-

hardt, Jamie Zimmeron, Colleen Kelley, Meg Eldridge, Grayson and Kathy James, Denise Barry, Kathy Park, Annie Leonard, Susan Stone, Kathy McFann, Monica Alifano, Vicki Zahn, Jim Farley, Tony Depalma, Pat Hendricks, Bruce Klickstein, David Gamble, Dana Davidson, Susan Hamilton, Robert Paton, and Sandy Jacobs. I'd like to thank the Friday morning class: Elizabeth Whitney, Melinda Lighthold, Rhiannon, Randy Schuler, Melissa Ward, Susan Stingle, Harmony Griswald, and Marsha Heron.

It was said to me when I first started training: "The mat is like a river, it won't stop for you to get in." I have had many turns in my river, and with them many teachers, each giving their unique gift to the student: Sensei Frank Doran, who got me on the mat patiently and showed me form. Sensei Bob Nadeau, who works with energy in the body, the known and the unknown. His teachings opened me to the possibilities outside myself, and opened my vision 360 degrees. Sensei Wendy Palmer grounds those possibilities in reality and works with how one can start to use this information in the world. In these classes I found my center, my home, and what I can do there. Sensei Richard Heckler, whose work with staying in the moment and taking that moment to the edge extended my limits by pushing me to that edge.

Visiting teachers who have graced the Bay Area Aikido, as well as local teachers who have enriched my training, include Senseis M. Saotome, H. Ikeda, Moriteru, Chiba, Tojima, Sasuki, Lorraine DiAnne, Mary Heiny, Linda Holiday, Pat Hendricks, Saito, Bruce Klickstein, John Stevens, Nakazona, George Leonard, Jack Wada, and Terry Dobson.

My deep appreciation to those who contributed privately to the making of this book and those who have helped me over the years so that I could create the images for this project: Barbra and Stanley Golden,

David and Adrianna Krauss, Peter, Kendra, and Molly Henricks, Jerry Friedman, Bill Barrett, Grayson and Kathy James, Donna Sheehan, Elizabeth Whitney, Melinda Lighthold, Tanis Walters, Roy Bonney, Melissa Ward, Louise and Frank Pepper, Rhiannon, T. Ogier, Larry and Pat Watson, and Ray Dobson.

I am blessed with a family that has given me space to grow, help me when they can (even when they don't understand or agree!), and loves me regardless, as I do them: Mary, Ron, Deva, Jacy, Isaac, Larry, Peggy, Cyras, Pris, Amber, Sarah, my Mother, Father, and Grandmother. Also, my extended family whose own rich lives nourish me: Claire Peaslee, Joyce Kouffman, Cheryl Dobbins, Sue Ann McKean, Elaine Yoder, Colleen Kelley, Robert Ott, Elizabeth Whitney, and Rhiannon.

I'd like to give special thanks to Grayson James for guiding me in the first phases of putting together this book, for mediating the first meeting and reviewing legal contracts. Thanks to David Gamble for his listening ear and the trip to Vermont, without which the tapes that became the stories would not have been done. Michele Linfante for her insightful wisdom in opening my vision of the book, her editorial assistance and layout suggestions. Elaine Yoder for her belief in the book as well as her critical insights in putting together the words and images. Bill Barrett for the final gorgeous cover. Elizabeth Whitney for her early editorial assistance and especially her constant belief in the project, which kept me focused. North Atlantic Books for seeing the potential, their creative support, and going with us all the way. Rhiannon for her inspiration, friendship, and love, who viewed and listened to all the changes, gave me her insights, undaunting encouragement, and belief in me and the project—which helped me to realize this dream. Riki Moss for opening her home and her heart, for picking up the pieces and pulling all this together; for trusting, lov-

ing, and surrendering. I'd like to give thanks to Terry Dobson for teaching through his life experience that Aikido is in me and all of us. His love and belief in the human potential helped me see my images and vision our collaboration.

I want to thank my companions past and present whose essence is always the gift of Aikido: Spencer, Drifter, and Weston—the dogs—for keeping me on my toes and loving me unconditionally. Uncle Gato, Moxie, Ming Ming, Fanny, Budda, Mattie, and Lil Bit—the cats—for being totally relaxed and loving me (conditions, yes). And to the Point Reyes area, its rolling hills, brackish bay, and endless ocean, for calling me to her side and giving me a place to call home.

<div align="right">

Jan E. Watson

August, 1993

Point Reyes, California

</div>